**Books should be returned on or before the
last date stamped below.**

FRANCIS BACON

Andrew Brighton

British Artists

Tate Publishing

Front cover: *Portrait of Isabel Rawsthorne* 1966 (fig.33, detail)

Back cover: *Three Figures and Portrait* 1975 (fig.38)

Frontispiece: Barry Joule, *Portrait of Francis Bacon* 1982,
Bacon photographed in 1982 standing next to a photograph of
himself taken by Helmar Lerski in Berlin in 1928, Barry Joule

Published by order of the Tate Trustees by
Tate Gallery Publishing Ltd
Millbank, London SW1P 4RG

© Tate Gallery Publishing Ltd 2001

The moral rights of the author have been asserted

ISBN 1 85437 307 2

A catalogue record for this book is available
from the British Library

Cover design Slatter-Anderson, London

Concept design James Shurmer
Book design Caroline Johnston

Printed in Hong Kong by South Sea
International Press Ltd

Measurements are given in centimetres, height
before width, followed by inches in brackets

CONTENTS

ACKNOWLEDGEMENTS

Some people listed below have helped by brief conversations, some by more protracted debates, some by papers they have given, and others have helped directly with my research and comments on the text: Dawn Ades, Ernst van Alphen, Bruce Bernard, Janice Blackburn, Catherine Brighton, Marc Cousins, William Feaver, Wilson Firth, Sarah Fox Pitt, Mathew Gale, Albert Herbert, Richard Humphreys, Sylvia Lahav, John Lavery, David Mellor, Alex Sainsbury, Rory Snookes, Julian Stallabrass, Juliet Steyn, David Sylvester and Jon Thompson. I learnt much from the attendees of the Bacon Course at the Tate Gallery in 1999 and the contributors to sessions on Bacon convened by Dr Martin Hammer at the Association of Art Historians Annual Conference 2000. The librarians at the Tate and Clare Hopkins, Archivist, Trinity College, Oxford, have been a great help. I hope my debt to the writings of others, particularly Michael Peppiatt's biography, is clear in the text and apparatus of this book.

INTRODUCTION

An atheist, Francis Bacon died of a heart attack, nursed by two nuns of the Servants of Mary, on 28 April 1992 in Madrid. He was eighty-two years old. Five days before his death he had flown from London, against his doctor's advice, to visit a young Spanish friend.

For the last thirty or more years of his life Bacon had been one of the most internationally celebrated artists of his time. He had major exhibitions in many of the great galleries of the world. His work was in many important museums and private collections. His paintings commanded some of the highest prices paid for the work of any living artist. The list of published writings on Bacon is huge. With Bacon's death the flood of words does not abate nor have the major exhibitions ceased. He is the subject of a feature film and the prices paid for his paintings remain among the highest for twentieth-century art.

Before he became famous and wealthy, Bacon's style of life was established. He traversed conventions of dress and social milieux; he mixed with toffs, toughs and the intelligentsia. He used make-up. He darkened his hair with shoe polish. Sometimes he dressed in Saville Row suits (suggesting membership of the British establishment), at other times he wore a leather jacket, then the garb of the bikers and hard men. Whatever his outer garb, he was given to wearing women's tights underneath.

After his death his body was cremated and his ashes flown back to England where they were scattered in a private ceremony without benefit of Church or State. He had always refused the honours the British establishment seeks to bestow upon its renowned subjects. According to one story, he was sounded out to see if he would accept one of the highest awards in the gift of the Queen, the Order of Merit. He turned it down with great camp dignity, 'No ducky, give it to someone else, it will give them so much more pleasure.'

★ ★ ★

Bacon scholarship is still raw. There is no secure and complete published list of his work on both canvas and paper. Bacon deliberately undermined the possibility of a definitive account of the meanings and motives of his work. Part of the fascination and importance of the primary Bacon text, *Interviews with Francis Bacon 1962–1979* by David Sylvester, the foremost writer on and curator of Bacon's work, is the way the artist resists the critic's insights when they get too like a stable interpretation. Further, Bacon's quoted autobiographical statements require scepticism: in the course of sociable nights buoyed on alcohol he did not let truth get in the way of a good anecdote, as the differing reported versions of incidents in his life attest. And, even when sober, Bacon misled people about his working procedures and suppressed information

about the sources of his work. He denied he drew. He kept certain works hidden from public view. Statements by Bacon are sites for excavation rather than sources of firm evidence.

<p style="text-align:center">★ ★ ★</p>

I have tried in this book to give the information, arguments and descriptions that might enrich a discussion, if only between the mind and itself, in front of Bacon's paintings. In the best of such conversations many kinds of information, ideas and descriptions are brought to bear. Interlocutors contribute a mix of visual descriptions and analyses, biography, social history, critical theory and other kinds of discourse. The painting prompts a complex of questions and answers. How does it work for us now? What were the sources technically and ideologically for its making? How does it relate to the work of others and other images? Why has it been celebrated, condemned or ignored by critics, historians and institutions? What ideas and values does our view of this work oblige us to hold and defend? The aim of such talk is then to open up the experience and significance of the work; it does not aim to be systematic or exhaustive. This activity resembles what Wittgenstein calls 'showing' rather than 'theorising'.[1]

1

PRETEXTS FOR DESPAIR

A Context of Despair

> I was seventeen. I remember it very, very clearly. I remember looking
> at a dog-shit on the pavement and suddenly I realized, there it is – this
> is what life is like. Strangely enough it tormented me for months, till I
> came to, as it were, accept that here you are, existing for a second,
> brushed off like flies on a wall ... I think of life as meaningless; but we
> give meaning during our own existence. We create certain attitudes
> which give it meaning while we exist, though they in themselves are
> meaningless, really.[1]
>
> <div align="right">Francis Bacon, Interview 5, 1975</div>

When Bacon emerged into major public recognition at the end of the Second
World War despair was in fashion. Continental Existentialism conjoined with
an English Neo-Romanticism that had been bemoaning the modern world
since the 1930s. Nietzsche was in vogue as a source for Existentialism. Bacon
read him seriously. When Bacon says we create attitudes that give life mean-
ing, he echoes Nietzsche's argument that after the death of God man must cre-
ate himself. His dog-shit revelation is the daily epiphany of depressives. It sets
the necessity of finding some drive, some source of conviction so compelling
that it will motivate action despite a sense of the self and existence as being
without value or meaning.

For many critics despair and pessimism was a valued attribute of an artist's
work. In the shadow of the atomic bombs dropped on Hiroshima and Naga-
saki, the writer Osbert Sitwell could write of the work of the painter Graham
Sutherland, 'a citizen of the sunset age, an Englishman, who saw the world's
great darkness gathering'. Sutherland was one of Bacon's closest friends, a
pictorial mentor, advocate and supporter at that time.

The most widely read British literary magazine of the 1940s was *Horizon: A
Review of Literature and Art*. It had a distinguished history of covering the
visual arts. In the final edition published in December 1949 there is an article
by the critic Robert Melville on Bacon and seven black and white reproduc-
tions of his paintings. He attributes to them a 'glimpse of the fires of despair
and frenzy'. The article sits between an essay on the Marquis de Sade by Mau-
rice Blanchot and a short story by James Lord, 'The Boy Who Wrote "No"', a
tale that ends with its subject paralysed and only able to twitch his defiance.
The magazine's editor, Cyril Connolly, in his introductory comment to the edi-
tion attributes to the Marquis 'the loudest and most interminable "No" in lit-
erature – No to God, No to Nature, No to Man'. He goes on to say that 'this
study in misunderstood genius leads us easily on to Bacon's horror-fretted
canvases'.

The substance of Connolly's editorial ends with a paragraph in which he speaks of the modern movement's struggle, 'between man, betrayed by science, bereft of religion, deserted by the pleasant imaginings of humanism against the blind fate of which he is now so expertly conscious'. He ends with a much quoted declaration that 'it is closing time in the gardens of the West and from now on an artist will be judged only by the resonance of his solitude or the quality of his despair'.

Bacon's early paintings have been seen as reflecting the War itself and in particular the images of concentration camps that emerged as the Allies liberated Europe in the latter part of 1944. One of the reproductions in *Horizon* was of the triptych, *Three Figures at the Base of a Crucifixion* (fig.1). It was completed in 1944, before the publication of the photographs of the camps, and Bacon had worked on it over a number of years. Thanks to co-exhibitor Graham Sutherland, it was first exhibited at the Lefevre Gallery in London in April 1945 a month before the end of hostilities. While he had exhibited and been reviewed in the 1930s, this exhibition marked the beginning of Bacon gaining a substantial public reputation as an artist. His work attracted notice; its affective power was acknowledged, even if its status as art was questioned. 'I have no doubt of Mr Bacon's uncommon gifts,' wrote Raymond Mortimer in a review of the exhibition in the *New Statesman*, 'but these pictures expressing his sense of the atrocious world into which we have survived seem to me symbols of outrage rather than works of art. If Peace redresses him, he may delight as he now dismays.[2]

But the paintings of these three malformed figures, like pacing lewd freaks caged in a bloody orange enclosure, did not simply have their origins in the horrors of war. Nor do the art-historical debts to, for instance, Picasso's biomorphic monsters of the late 1920s (see fig.13) and the horrific *Mocking of*

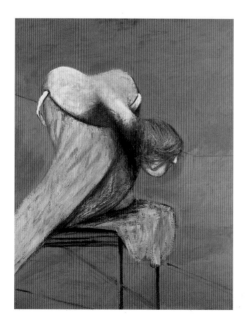

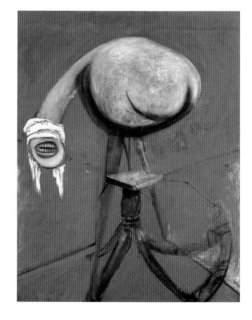

Christ (Alte Pinakothek) by Mathis Grünewald (*c.*1510–15) tell the whole story. That the three figures are, as Bacon declared, the Eumenides (the Greek Furies) from Aeschylus's *Oresteia* also adds connotative resonance. These were the resources for Bacon's visual articulation of an ideology, one that the War had not brought and peace would not redress. The culture of pessimism helped to nurture Bacon's recognition, but it was the context not the pretext of his rhetoric of despair. It was not the source of his necessity, conviction and motivation: their origins came earlier.

Origins of Despair

> *David Sylvester*: Perhaps you'd tell me what you feel your painting is concerned with besides appearance.
> *Francis Bacon*: It's concerned with my kind of psyche, it's concerned with my kind of – I'm putting it in a very pleasant way – exhilarated despair.[3]

Interview 3, 1971–3

Francis Bacon was born into a dying caste, a social stratum that was enmeshed in a declining empire and enjoyed aristocratic privileges over subject peoples. Bacon's boozing, bullying, opinionated and gambling father had made a career as an officer in an army of colonial occupation. Grandson of a general, son of a captain in the Hussars, Captain Anthony Edward Mortimer Bacon had served in Ireland and South Africa then returned to Ireland to own, breed and train racehorses after his financially astute marriage and retirement from the army. Born in Dublin in October 1909 to English parents, Francis Bacon was British but at the time the country of his birth was in the violent process of achieving statehood independent of Britain. As members of the

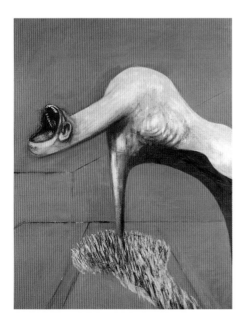

1 *Three Studies for Figures at the Base of a Crucifixion* 1944
Oil on board Each panel 94 × 73.7 (37 × 29) Tate

11

colonial class, Bacon's family and relatives were under threat of attack during his childhood. The Irish conflict and subsequent independence foreshadowed many such conflicts across the globe as the forces of national independence dismantled the British Empire. If Bacon had followed the conventional path of his background he might, for instance, have become a colonial official like his elder brother, with a life eased by servants and a private income over and above salary. He could have ended his days in the last bastions of the colonial way of life in southern Africa where his sisters and, after his father's death in 1940, his mother were to spend their later lives.

The industrially derived wealth of his mother Winifred's family, the Firths, supported the Bacons' form of country life in Ireland. Bacon referred to his father as a failed horse-trainer. However, the Bacons' claim to an aristocratic form of life derived not just from money and colonial privileges. The family was descended from Sir Francis Bacon, Baron Verulam, Viscount St Albans (1561–1627), the seventeenth-century lawyer, scientist, essayist and philosopher. Francis enjoyed the idea of his own aristocracy and his forebear's reputation for homosexuality, extravagance and the suggestion that he might have written Shakespeare's plays.

The horse-enthusiastic English upper class is a stratum known for its lack of interest in and often hostility to modern high culture. However, they did and do support a subculture of equestrian art. When the racehorse painter Sir Alfred Munnings attacked modern art in his presidential speech at the Royal Academy of Arts annual dinner in 1948, it was to the common sense of his clients that he appealed in his denigration. In his paintings he depicted well-bred horses and people mixed in with jockeys, gypsies and others who worked around or followed the horses (fig.2). This equestrian way of life cut across the socially high and low as Bacon was able to do in his own social and sexual life. What is absent from the social world Munnings painted and his conception of art was the professional middle classes and in particular the values of the intelligentsia. To the social stratum of origin into which Bacon was born Munnings's work represented the acceptable face of art.

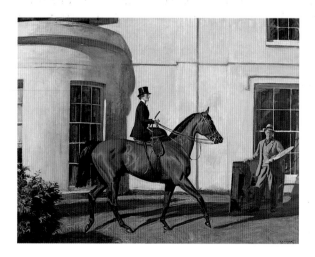

2 Sir Alfred Munnings
My Wife, My Horse & Myself 1932–3
Oil on canvas
101.6 × 127
(40 × 50)
The Sir Alfred Munnings Art Museum, Castle House, Dedham, Essex, England

Childhood Horrors

Bacon was the author of his own childhood. That is to say, he chose to make public stories of his childhood as a mixture of neglect, threat, violence and rejection. Published in 1964, the first book on Bacon included a brief anodyne biographical sketch. It took the form of a catalogue raisonné, a scholarly listing of his work up to 1963 written by the then Director of the Tate Gallery, Sir John Rothenstein, and the Keeper of the Modern Collection, Ronald Alley.[4] It is the kind of publication usually reserved for the distinguished near dead or dead artist. The authors and the form of the book are an indication of the enterprise and influence of the gallery where he had been exhibiting his work since 1960, Marlborough Fine Art Ltd.

The publication of major biographical revelations begins with John Russell's excellent Bacon monograph in 1971.[5] Homosexual acts ceased to be illegal between consenting adult males in England in 1968 and so stories of such incidents could no longer be used as potential evidence for a prosecution. By describing his life in the way he did, Bacon contrived or at least allowed a situation to develop in which his work would in part be understood in the light of his own autobiographical stories. They became the pretext for his persona as an artist.

From his accounts of his childhood Bacon was an abused child. He claimed to have had little or no parental affection and some brutality. His parents came to detest each other. Entrusted to a local Protestant clergyman of no great academic enthusiasm, his education was desultory. Because of asthma, from which he suffered all his life, Bacon could not join in his father's equestrian activities; proximity to horses and dogs sparked acute attacks. Yet he claimed his father forced him to ride. Bacon said that he disliked his father but that he also desired him sexually. He alleged to a friend that his father had him regularly thrashed by the grooms. Only in his middle teens did Bacon attend boarding school for five terms between 1924 and the spring of 1926.

Having created the story of his childhood, Bacon refers to this account in his paintings. A kinship of deformities suggests a mother and child in *After Muybridge – Study of the Human Figure in Motion – Woman Emptying a Bowl of Water/Paralytic Child Walking on all Fours*, 1965 (figs. 3, 4). The figures gambol on a racecourse fence; the down-struts curve away from the track to avoid injury to falling horses and jockeys. Further, the curved orange plane that forms the back of the irrational perspective frame is an abstracted version of the curved back walls in other paintings derived, Bacon suggested, from the curved windows of his grandmother's house.

The Fall from Family

Bacon's account of his family upbringing ends in 1926 at the age of sixteen. His father discovered him dressed in his mother's underwear and expelled him from home. Since his early teens Bacon had been an active homosexual in relationships with his father's grooms. With an allowance of three pounds a week from his mother, enough then to live on, he departed for London.

3 *After Muybridge – Study of Human Figure in Motion – Woman Emptying a*
Bowl of Water/Paralytic Child Walking on all Fours 1965
Oil on canvas 198 × 147.5 (78 × 58⅛) Stedelijk Museum, Amsterdam

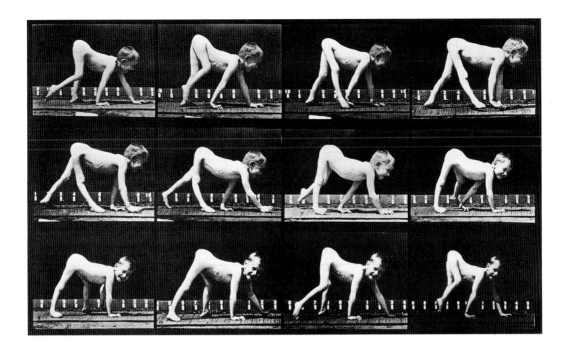

4 Eadweard
Muybridge
*Infantile Paralysis
Child Walking on
Hands and Feet*
Photograph
Muybridge *Complete
Human and Animal
Locomotion* Vol.II,
Dover, plate 539

These stories have been important to the reception of Bacon's paintings, linked both to his masochistic sexuality and to the violence and pessimism attributed to his work. They emotionally authenticate the character of the paintings. However, Bacon's stories call for some scepticism. Michael Peppiatt, who has written the most reliable biography of Bacon, quotes from a school contemporary of Bacon who describes him as socially assured and sophisticated, interested in the turf and academically undistinguished rather than incompetent. The cruelty Bacon describes when placed in the context of his class is not that exceptional: most male members were sent away to school even before reaching their teens and many were beaten, bullied and some sexually abused.

We know that Bacon read Freud, who may have been a source for his understanding of his sexuality and for his accounts of his childhood. Freud's essay 'The Economic Problem of Masochism' was available in English translation from 1924. In that essay Freud suggests that masochism may arise from the retention and confusion of two phases in the development of a child: parents as objects of libidinal desire and their subsequent role as lawgivers. In his discussion of what he calls moral masochism he argues that the child translates a sense of guilt into a wish for parental punishment, a wish expressed in fantasies of beatings by the father and of having 'a passive (feminine) sexual relation to him'.[6]

15

Sex and Art in Berlin and Paris

David Sylvester wrote in a biographical note for the 1998 exhibition *Francis Bacon: The Human Body*:

> In 1926 he left home, initially travelling with a friend of his father's with whom he spent several months in Berlin. He went on to Paris, where he started making drawings and watercolours after seeing an exhibition of Picasso drawings in the summer of 1927. In order to get some mastery of French he spent three months with a family near Chantilly.[7]

This survival of the Grand Tour when the aristocracy rounded off their offspring's upbringing sounds like an enviable piece of post-school education arranged and supported by his parents.

Bacon's stories of these years are more lurid. We know Bacon left school in April 1926 when he was sixteen, thanks to Michael Peppiatt's research. Expelled from home, he was in London for a time but was in Berlin by spring 1927. He would have been seventeen. For both his art and his sexuality, biographers have argued, the two or three months Bacon spent in Berlin were to be significant. In the late 1920s and early 1930s Berlin was a destination for homosexual excursion: in W H Auden's words, 'Berlin was the buggers' daydream'.[8] A literature and a mythology grew up around the city that may have coloured Bacon's reminiscences. In Bacon's account the friend of his father was a manly man intended to show him the heterosexual straight and narrow. However, Bacon claimed, 'he used to fuck absolutely anything', including Bacon himself.[9] His deviant chaperon took him to night clubs catering for all sexual proclivities. What is clear is that in the late 1920s Bacon lived briefly in a city that accepted his sexuality as London was not to do until the last quarter of the twentieth century. Berlin may well have been a source for the courage to assert his particular form of sexuality.

If there is one decision Bacon made that determined the character of his art, it was, like Picasso, that he made his sexuality the core of his paintings. His masochistic homosexuality was a resource for his work, including his statements about the effect he wanted his work to have. The work addresses our bodies, not just the eye and the mind. In his descriptions of painting and responses to painting, he frequently uses 'violent' and other metaphors of assault. Bacon seeks to 'come immediately onto the nervous system', thereby to 'unlock the valves of feeling and therefore return the onlooker to life more violently'.[10] Bacon's rather mechanical metaphors, 'nervous system' and 'valves of feeling', probably have their origin in Freud's picture of instinctual life as a mechanism of circulating energies. Nevertheless, Bacon's picture is more convulsive and physiological. To some degree, for him art aspires to the condition of his form of sexuality.

Did Bacon see the work of Otto Dix, George Grosz and Max Beckmann and the photomontage of Hannah Hoch and other Berlin Dadaists while he was in Berlin? A positive answer attributes to the seventeen-year-old Bacon an improbable level of cultural luck, competence, prescience and courage. The

fractured space of Dadaist photomontage, the evocation of disgust by Grosz and Dix and the sheer pictorial ambition of Beckmann did help to form the pictorial vocabulary and values that made Bacon's later work possible. However, there is little sign of such influences in his work of the 1930s, and it seems unlikely that he had any serious encounter with these artists or their work in Berlin.

The first report we get of Bacon actually making images is after he saw an exhibition of Picasso drawings at Paul Rosenberg's Gallery in Paris in the summer of 1927. Biographers believe, partly due to Bacon's own claims, that this exhibition included some of Picasso's globular figures, which began in 1927. They are arguably the major single art source for Bacon's work. Michael Peppiatt, however, has pointed out that the Rosenberg exhibition did not include any biomorphic or indeed Cubist pieces.[11] It consisted of Picasso's neo-classical images. It was Picasso at his stylistically and socially most reactionary that provoked Bacon to make watercolours and drawings himself.

Bacon's stories of his traumatic childhood and early sex life may have been told for their own sake – honest and cathartic revelations and fibs – but they give us one of Bacon's pretexts. By word of mouth and in published sources his account of himself increasingly accompanied him and his work. They lent authenticity to his art and its rhetoric of despair. They tell us something both of how he wanted others to understand his history and of how he understood it himself. These understandings became sources for his paintings; they are in a sense part of the 'literature' on which his work drew.

IDEOLOGIES OF DESPAIR

Back in London

Bacon returned to London in late 1928 or early 1929. He lived and worked in a converted garage in South Kensington. He had furniture and carpets made to his own designs and exhibited them in his studio. Consequently in *The Studio*, August 1930, a brief article appeared on Bacon as a designer (fig.5). So within eighteen months of arriving in London, not yet twenty-one and without formal art training, Bacon had the skill to design, the capital to have made and the audacity to have exhibited and publicised his work as a modernist designer.

The first known painting of Bacon's, *Watercolour*, 1929 (fig.6), is so eclectic that every commentator nominates different influences: Giorgio de Chirico, Paul Nash, the Purist aesthetic geometry of Fernand Léger and Le Corbusier paintings (the latter's design work was a source for Bacon's furniture), and of course Picasso. What sort of skills does this untrained artist exhibit in the work? In terms of manual dexterity this is not a difficult work to make: the colour is flat and much of the drawing is ruled with a straight edge. There are no gradations of colour or tone and no volume in space to draw. Two things are impressive: the complex asymmetry of the composition and the grasp of both positive and negative space. Most neophytes when they draw objects are unaware that they are also drawing the shape of the space in which the object exists. Probably by intelligent copying, Bacon acquired a sophisticated pictorial understanding. Corroboration of this suggestion comes from John Russell's observation that one of his carpets of about 1929 was almost a straight paraphrase of a complicated Synthetic Cubist painting by Picasso.

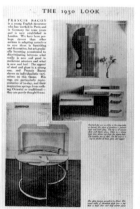

5 *The Studio* August 1930
Pages 140–1
Photograph

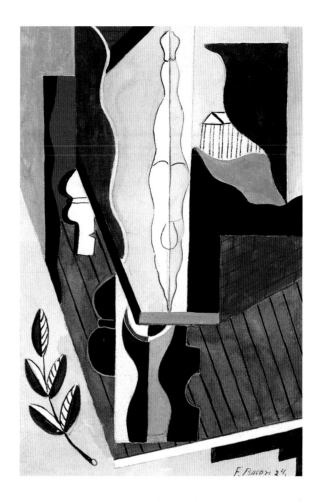

6 *Watercolour* 1929
Watercolour and
bodycolour
21 × 14 (8¼ × 5½)
Private Collection

The Artist

Formative of Bacon's practice and of what he said about it was the idea of 'The Artist' that was current when he became a painter. The artist as a special being with an intuitive route to their authentic personality was a cliché of the educated. In 1933 in his pioneering book *Art Now*, which included a reproduction of a Bacon painting, Herbert Read surveyed the philosophical and theoretical origins of modern art and discussed the variety of its practice, ending with the question: 'Does that leave us with any one element common to all great pictorial art, the peculiar possession of all genuine artists?' He answers this himself:

> It is the capacity to allow the personality to express itself in the
> craftsmanship: some mysterious equivalence between thought and
> action. The act of putting pencil to paper, brush to canvas, becomes an
> act of what Croce has called lyrical intuition, and in that act, in that
> instant, the personality, and indeed, the spirituality of the artist is
> revealed.[1]

Benedetto Croce (1866–1952) was the most influential aesthetician of the

twentieth century. He has now virtually disappeared from academic attention. An implicit function of Read's book was to establish grounds for denying the status of artist to traditional practitioners. He was waging war on the likes of Munnings, the Royal Academy and the tastes of the plutocracy for the cause of modern art and progressive intellectuals. This led him to cite Croce as supplying a definition of the 'genuine' artist: someone who produces work by particular cognitive processes. The argument invites artists to present themselves as having mysterious mental characteristics, abilities that are beyond rational account, and to display, for instance, the loss of self-awareness that is characteristic of many acts of doing or making as 'lyrical intuition'. In 1945 the state support for contemporary art that Read and other progressives had advocated was established in the UK. The architect of the Arts Council of Great Britain, the economist Maynard Keynes, broadcast to the nation: 'The artist walks where the breath of the spirit blows him. He cannot be told his direction; he does not know it himself.'[2]

The relationship between words and visual art is various, complex and fundamental. Bacon was inclined to deny the degree that artists' words matter, particularly the extent to which discussion is the matrix for art practice. He thought and spoke, however, about what he was doing a great deal, although, once formulated, his views apparently remained fixed; he reiterates, for instance, in later interviews with others ideas and phrases we first encounter in the Sylvester conversations.

He could 'cleaver the heart of a book faster than any Oxford Don', claimed his friend Barry Joule.[3] Artists of Bacon's generation were rarely systematic readers. Such a basic academic exercise as critically analysing or summarising a text was not part of their post-school education. They were not required to master texts with which they disagreed. They read literature and particularly philosophy to find sympathetic ideas and supportive and enabling arguments and exemplars. Less formally educated than many of his contemporaries but more intellectually able than most, Bacon had a selectively absorbent mind. When John Russell declares of Bacon, 'he has never finished a bad book, he has never entertained a dull thought and has never made a commonplace remark', minus the hyperbole he is describing a particularly intelligent form of this self-centredness.[4] Bacon's theorised ideology was a construction derived from unsystematic reading and hearing the opinions of others better formally educated than him, filtered through an acute sense of his self-interest as an artist.

Until Bacon's death, due to his own insistence and influence, retrospective exhibitions and publications downplayed him as a painter before 1944, i.e. before *Three Studies for Figures at the Base of a Crucifixion* (fig.1). He had destroyed much of his early work. What remain are the few paintings he sold or gave away during the 1930s. As if intuition and 'the breath of the spirit' created him, Bacon covered up the sources from which he acquired his cultural and art knowledge. He denied the importance of the staff, as it were, of his informal art school. There are two important figures, Roy de Maistre (1894–1968) and Eric Hall (1891–1959). In the course of this book I shall refer first to de Maistre and then at the end to Hall in considering Bacon's work

7 *Composition (Figure)* 1933
Gouache pastel and pen and ink on paper
53.5 × 40 (21 × 15¾)
Marlborough International Fine Art

beyond the years of his relationships with them. I am arguing that by the end of the 1940s much of Bacon's ideology was formed. His work thereafter continued to explore his notion of how things were and the vein it had opened into the potentialities of painting, but by then the ideological die was cast.

Roy de Maistre

When they met in 1930 Roy de Maistre was thirty-five, Bacon was twenty. An Australian, de Maistre was among the first artists in Sydney to be aware of Post-Impressionism. After the First World War he had exhibited and sold work, and taught in Australian art schools. He initially came to Europe in the mid-1920s and returned permanently at the end of the decade. He had his first London one-person exhibition in July 1930 and then showed with Bacon in Bacon's studio at the end of the year. De Maistre knew much of what Bacon needed to know. He was his first and arguably most formative mentor.

The underestimation of Roy de Maistre's importance to Bacon was because both men wanted it so. For Bacon to admit that he had learnt a great deal both technically and ideologically from a mediocre painter from the colonies was less than conducive to the myth of his untaught genius. In the post-1945 period it was not opportune for de Maistre to advertise his past close association with a man who was an overtly homosexual atheist with criminal associations and a taste for rough trade. De Maistre became a Roman Catholic in 1949. He painted Church commissions. He was 'a homosexual of extreme discretion' according to David Ward, the biographer of another of Roy de Maistre's protégés, the Nobel Prize winning novelist Patrick White.[5]

De Maistre was surprised that Bacon, who had a sophisticated appreciation of Picasso, would ask him technical questions that most schoolchildren could

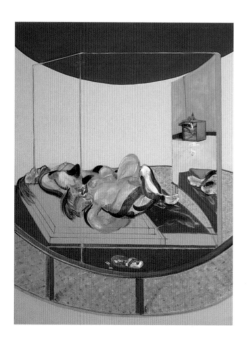
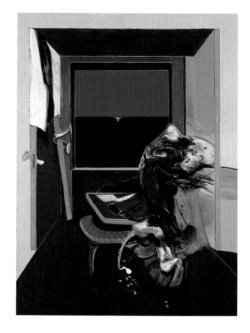

8 Roy de Maistre
Studio Interior 1931
Oil on canvas
50.5 × 60.6
(19⅞ × 23⅞)
Art Gallery of New
South Wales,
Australia; Gift of
Patrick White 1974

answer. In particular, de Maistre helped Bacon with oil painting. De Maistre
was rather pedestrian in the way he painted in oils; he essentially filled in his
linear drawing. The paint lacks independent life. Technically both men at that
time were best in watercolour and pastels, essentially coloured drawings.
Bacon's most accomplished works of the 1930s, for example *Composition*, 1933
(fig.7), combine this technique with Picasso-like biomorphic figures.

De Maistre's importance to Bacon's work was more than simply technical.
In a painting that belonged to Patrick White, *Studio Interior*, c.1931 (fig.8), de
Maistre prefigures Bacon's paintings of coupling male figures observed, as in,
for instance, the left-hand panel of *Triptych Inspired by T.S. Eliot's Poem
'Sweeney Agonistes'*, 1967 (fig.9). There were other de Maistre paintings in this

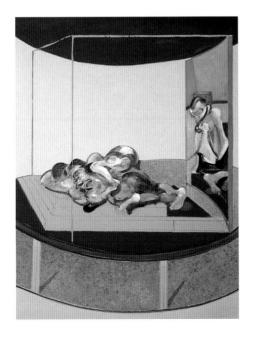

9 *Triptych Inspired by T.S. Eliot's Poem
'Sweeney Agonistes'* 1967
Oil on canvas
Panel A 198.8 × 148.3 (78¼ × 58⅜)
Panel B 198.8 × 148 (78¼ × 58¼)
Panel C 200.3 × 148 (78⅞ × 58¼)
Hirshhorn Museum and Sculpture Garden, Smithsonian
Institute; Gift of the Joseph H Hirshhorn Foundation 1972

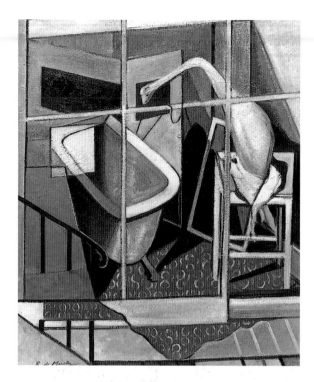

10 Roy de Maistre
Figure by a Bath
*c.*1937
Oil on board
64 × 54
(25¼ × 21¼)
Private Collection

genre, of 'fellas doing things to fellas', to quote his biographer Heather Johnson, which, she reports, were destroyed by the executors of his will.[6]

Roy de Maistre's *Figure by a Bath*, 1937 (fig.10), suggests something of broader significance. The globular figure in de Maistre's painting resembles Bacon's destroyed *Abstraction, c.*1936 (fig.11), *Figure Getting out of a Car, c.*1943 (fig.28), and the central figure of *Three Studies for Figures at the Base of a Crucifixion*, 1944 (fig.29). They are the prototypes of the Furies and Harpies, the vengeful agents of guilt that reappear in Bacon's work in different forms over the years. A shared iconography is an indication of a period of such intellectual and professional intimacy that Bacon's debt to de Maistre clearly went beyond the technical.

John Rothenstein wrote of Roy de Maistre: 'Not many who know him now suspect that in the most significant sense, aristocrat though he is, he is a self-made man. His establishment in Europe, his personality as an artist, are the consequences of acts of faith and will; so too is his membership of the Catholic Church.'[7]

Joseph de Maistre

Count Joseph de Maistre (1753–1821), the irrationalist political theorist from Savoy, was central to Roy de Maistre's self-making. Roy de Maistre was baptised as LeRoi Leviston de Mestre; he changed his name to de Maistre and added Joseph to the list of his forenames in 1930, the year that he met Bacon. Roy de Maistre could speak some French and at least two of Joseph de Maistre's books existed in translation. Patrick White, who met and became a

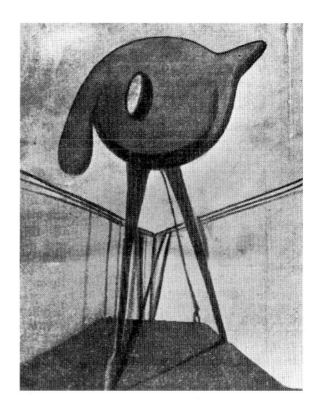

11 *Abstraction*
*c.*1936
Oil on board
Probably 94 × 74
(37 × 29)
Destroyed

lover of Roy de Maistre in 1936, provides further evidence of the importance of Joseph to Roy and to Roy's considerable influence on his acolytes.[8] In 1938 White visited Savoy with the idea of writing a novel about Joseph de Maistre. White, who was better educated and older than Bacon when he met Roy, nevertheless described Roy as formative of his intellectual life.

Joseph de Maistre's thought was formed in bitter and radical opposition to the French Revolution and its origins in the Enlightenment. Whereas Enlightenment thinkers looked to reason as the means by which humanity might take charge of its fate, Joseph de Maistre considered that humankind since the Fall had lost its knowledge of God's order: our fallen condition is inherently irrational. He saw incoherence as a given of nature and history, manifested in violence, savagery and murder. Isaiah Berlin wrote of Joseph de Maistre:

> Maistre conceived of life as a savage battle at all levels, between plants
> and animals no less than individuals and nations, a battle from which
> no gain was expected, but which originated in some primal,
> mysterious, sanguinary, self-immolatory craving implanted by God.
> This instinct was far more powerful than the feeble efforts of rational
> men who tried to achieve peace and happiness (which was, in any
> case, not the deepest desire of the human heart – only of its
> caricature, the liberal intellect) by planning the life of society without
> reckoning with the violent forces which sooner or later would
> inevitably cause their puny structures to collapse like so many houses
> of cards.[9]

25

What could draw Bacon to the world-view of Joseph de Maistre beyond simply the fact that it was imparted by his friend Roy de Maistre? Why might Joseph de Maistre be a primary source for the ideology of Bacon's work? The answer is that he offered Bacon ideological continuity. He spoke for the values of Bacon's own class of origin, and of the reality of instinct against the delusions of reason. Further, he was deployable cultural capital: for any non-Catholic outside France knowledge of Joseph de Maistre gave access to a Catholic vision that was fundamental to modern French literature and in particular to Baudelaire.

'De Maistre and Edgar Poe have taught me to reason,' wrote Baudelaire in *My Heart Laid Bare* which forms part of the *Intimate Journals*. T.S. Eliot gave centrality to the de Maistrian aspect of Baudelaire in his introduction to Christopher Isherwood's translation of *Intimate Journals* published in 1930:

> Baudelaire perceived that what really matters is Sin and Redemption
> ... the recognition of Sin is a New Life, the possibility of damnation is
> so immense a relief in a world of electoral reform, plebiscites, sex
> reform and dress reform, that damnation itself is an immediate form
> of salvation – salvation from the ennui of modern life, because it gives
> some significance to living.[10]

De Maistre offered to Bacon and the circle of gay men around Roy de Maistre a kind of absolution through universal guilt. They found themselves driven by desires regarded by church, state and society as an abomination, as perverse, disgusting, criminal and evil. Joseph de Maistre offered a vision of all humankind lost in evil and bearing the guilt of original sin, a vision with which Roy de Maistre and his circle could identify.

The Executioner

God for Joseph de Maistre was 'an angry power, and this power can be appeased only by sacrifice';[11] 'man being thus guilty through his *sensuous principle*, through his flesh, through *his life*, the curse fell on his blood, for blood was the principle of life, or rather blood was life'.[12] Redemption by blood sacrifice, was a means of atonement for evil. Modern human sacrifice took the form of war and execution. An image of human sacrifice is a repeated motif in both Bacon's and Roy de Maistre's paintings, the image of crucifixion. Joseph de Maistre saw the executioner as the officiating priest at the altar of atonement. He describes the executioner's work in his most celebrated and quoted passage:

> He arrives at some public place packed with a dense and throbbing
> crowd. A poisoner, a parricide, or a blasphemer is thrown to him;
> he seizes him, he stretches him on the ground, he ties him onto a
> horizontal cross, he raises it up: then a dreadful silence falls, and
> nothing can be heard except the crack of the bones breaking under
> the crossbar and the howls of the victim. He unfastens him; he carries
> him to the wheel: the shattered limbs interweave with the spokes; the

head falls; the hair stands on end, and the mouth open like a furnace, gives out spasmodically only a few blood-spattered words calling for death to come.[13]

In Bacon's extant paintings crucifixions figure by name from 1933 until 1965. Of the fourteen extant works before 1944, Bacon named three crucifixions. In another five paintings figures hold out their arms in a possibly cruciform way, but they appear animated and are probably derived from Picasso's *The Three Dancers*, 1925 (fig.12), which, however, has been interpreted as a Dionysian scene of crucifixion.

In April 1933 a crucifixion by Bacon was included in an exhibition at the Mayor Gallery in London. Later in the same year it was reproduced in Herbert Read's book *Art Now* (fig.13); pointedly Read placed it opposite Picasso's *Baigneuse*, 1929. *Crucifixion*, 1933 (fig.14), depicts two figures, one attached to a cross, the other standing on the same level attending to the other. Similarly, in *Painting*, 1946 (fig.36), we look up at the foreground figure sitting before the crucified carcass; the perspective of the picture raises them up as if on a podium. If he were to stand, he would be on the same level as his victim. As in later crucifixions, the body is opened up into a bloody carcass. Someone or thing has worked cruelly upon these constrained bodies.

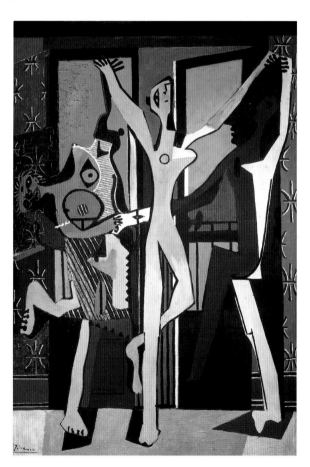

12 Picasso
The Three Dancers
1925
Oil on canvas
Support
215.3 × 142.2
(84¾ × 56)
Tate

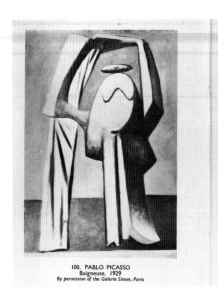

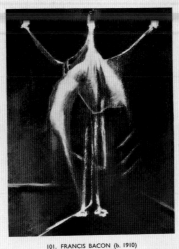

100. PABLO PICASSO
Baigneuse. 1929
By permission of the Galerie Simon, Paris

101. FRANCIS BACON (b. 1910)
Crucifixion. 1933
By permission of the Mayor Gallery

Bacon was a kind of realist; he sought to show the 'brutality of fact', the reality of things rather than just appearances.[14] His vision of reality denied the progressive hopes of many of his generation of intellectuals as well as the comfort of conservatism or even the possibility of redemption that was allowed in Joseph de Maistre's Christianity. So militant an atheist was he that when a book by a friend, the late Bruce Bernard, was on the verge of publication he stopped it because of his writing about religion and Bacon.[15] Few British intellectuals held such an overt, persistent and aggressively disenchanted view of the world. There is little precedent for it in British art and literature. Bacon starts to articulate this ideology in his early work when he was close to Roy de Maistre. Joseph de Maistre is a likely formative source for Bacon's ideas even if they only came via Roy, and Joseph's terrible description of an execution may have been a source for Bacon's many images of sacrifice.

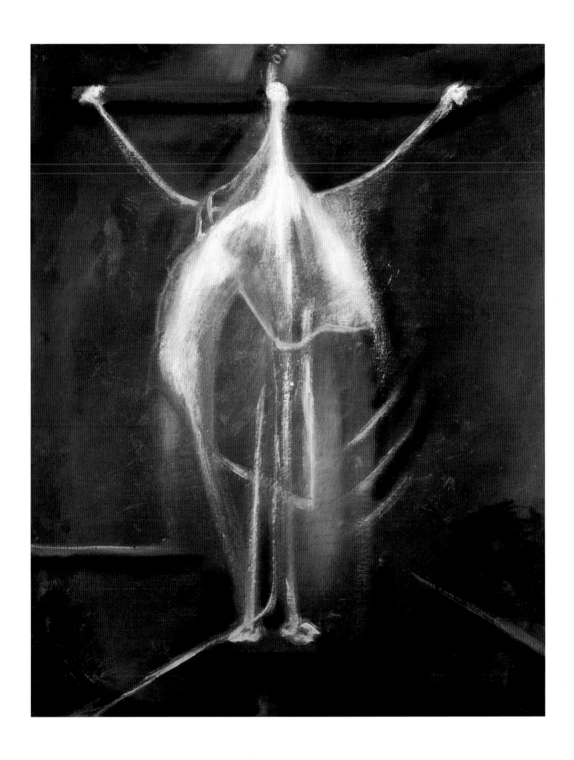

14 *Crucifixion* 1933
Oil on canvas 62 × 48.5 (24¾ × 19)
Private collection

BACON'S DIFFERENCE

Art is a method of opening up areas of feeling rather than merely an
illustration of an object ... Real imagination is technical imagination.
It is in the ways you think up to bring an event to life again.[1]

<div align="right">Francis Bacon in an interview in Time, New York, 1952</div>

Into the Field of Contesting Values

While histories of modern art and the hanging policy of museums tend to
suggest a view of art as following settled lines of development, the art world is
in practice a field of contesting values and evaluations. In discussing Bacon's
work of the late 1940s to 1960s, I want to locate it in relation to some of the
then current conflicts of art practice and criticism. I want to show how indis-
soluble was Bacon's ideology and the way his work was made.

The art historian, painter and one-time Professor at the Slade School of
Art, Lawrence Gowing, commented that the impact on some painters of
Bacon's first one-person exhibition at the Hanover Gallery in 1949 was 'inde-
scribable':

> It was an outrage. A disloyalty to the existential principle, a mimic
> capitulation to tradition, a profane pietism, like inverted intellectual
> snobbery, a surrender also to tonal painting, which earnestly
> progressive painters have never forgiven. It was everything
> unpardonable. The paradoxical appearance at once of pastiche and of
> iconoclasm was indeed one of Bacon's most original strokes.[2]

One reason for Bacon's offence was the promiscuity of his sources in general
and his use of photography in particular.

Bacon's pictorial sources traversed mediums and traditions. From medical
textbooks on diseases of the mouth and positions in radiography to Michelan-
gelo drawings, from film stills to Degas pastels and paintings, from newspaper
shots of shouting politicians to Rodin sculpture, from boxing and Muybridge
photographs of bodies in movement to Rembrandt and Velázquez paintings,
from Picasso's work of the later 1920s and early 1930s to photographs he com-
missioned of lovers and friends, these and many other images fed his work.

The photograph of the man with a monkey shown in fig. 15 was a source for
Head IV (Man with Monkey), 1949 (fig. 16), one of a series of six entitled *Head I*,
Head II and so on to *Head VI*. The dealer who exhibited the *Head* paintings in
1949 was Erica Brausen, who had just opened the Hanover Gallery. She sup-
ported and promoted Bacon from the late 1940s until 1960. She encouraged
him to produce paintings for exhibitions, she worked to sell them to public and

15 Sam Hunter
Some very varied
clippings in Francis
Bacon's studio
photographed by
Sam Hunter in the
summer of 1950.
They include from
left to right: (top
row) photographs of
Himmler and
Goebbels from
Picture Post; the
aftermath of a riot in
1916, one of the
injured; Velázquez's
portrait of Pope
Innocent X; the
famous photograph
of Baudelaire by
Nadar; (centre row)
a plate entitled
'Vaudeville Films –
"Facials" and Close
Ups' from *The History
of the British Film
1896–1906* (London
1948) by Rachel Low
and Roger Manvell;
Grünewald's *Christ
carrying the Cross* in
the Kunsthalle,
Karlsruhe; people
rushing for shelter
during street fighting
in Petrograd, 17 July
1917; (bottom row)
Rodin's *The Thinker*;
a photograph of
hippopotamuses
from Marius
Maxwell's *Stalking
Big Game with a
Camera in Equatorial
Africa* (London 1924)
Photograph
Sam Hunter

private collections, lent him money and bought his work as gallery stock. Bacon's production was spasmodic. He destroyed what he took to be failed paintings. Between the photograph of the man holding a monkey and *Head IV* may lie many destroyed canvases.

Part of the intensity of his paintings up to the mid-1950s is that they hover on the edge of incompetence, on the edge of failed pastiche. Much of *Head IV* is thinly and cursorily painted. The forms of the man, the monkey and the curtain were probably drawn first in pastel onto the unprimed raw canvas, then re-drawn with black paint. With a thin white line he indicates a perspective space frame at odds with the symmetry of the composition and the confines of the painting's edge. In the black wash that forms the darkness between the curtains and the back of the man the drawing is still discernible. The next conventional move would have been to build up the rounded shapes of the head and shoulders and he does begin to suggest the shoulders and back. But Bacon uses the transparency of the head and also the way the darkness between the

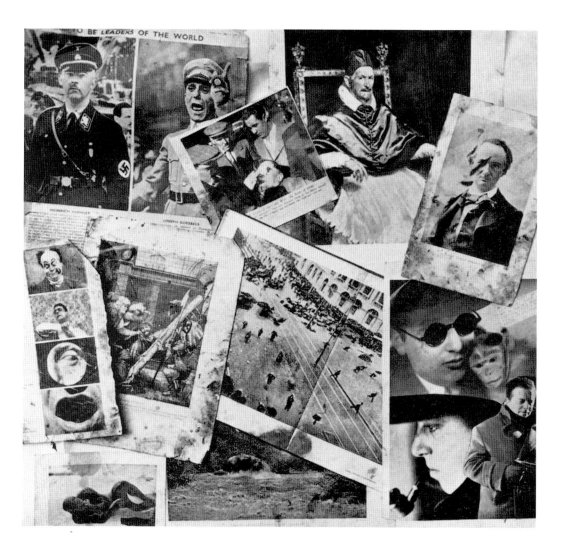

16 *Head IV (Man with Monkey)* 1949
Oil on canvas 81 × 66 (32¼ × 26)
Private Collection

curtains creates a hairline on the side of the head. He teases the head into three dimensions by painting an ear in highlights and indicating the side of the forehead with a small burst of white. Reasserting one of the lines of the drapery locates the front of the face. He revisits the back of the head with a scumbled white line but leaves the ghost of its previous black delineation. When he does paint the man's shoulders and back in lighter tones, he picks up the line of the right curtain by leaving a crevice of black.

The intelligence and courage of *Head IV* and the paintings of the late 1940s to the mid 1950s lie in Bacon's use of his own ineptitude and his limited painterly virtuosity. He exploits the seductive plasticity of silver-grey to black, giving that sense of form made by laying lighter tones onto dark. He recognises the affective power of his pictorial transgressions in his stumbling construction of conventional form and space. He grasps them and teases them into greater vivacity. This is intelligent because of his acute attention to what he is doing. It is courageous because the whole enterprise hangs on a knife-edge and is entirely reliant on his ability to find something in the paintings that saved them from looking like the work of an under-trained painter working from photographs. That, of course, is what he was. The paintings he destroyed were no doubt the paintings that gave him away.

Painting into Dark, 1949

Bacon was to develop as primarily a tonal painter up to the mid-1950s. Structuring by tone and limiting hue simplifies technical problems but it is the vocabulary of form illuminated by directional light in pictorial depth. It is the antithesis to appearance rendered primarily by hue as in Monet or Pissarro. Since the Impressionists most artists have painted onto smooth, white-primed canvas. This maximises the vivacity of hue but can deprive dark tones of depth. Bacon painted onto brown un-primed canvas, onto a mid-toned ground. Before Impressionism most painters worked on canvases primed in a mid-tone. It provides a key tone against which dark and light tones are disposed. Bacon painted, in other words, as if Impressionism had never happened. In the early 1950s he started his practice of painting on the 'wrong' side of the canvas, that is, the side where the tooth of the material provides a rough texture, making the passage of the brush more explicit.

Gowing, in his account of artists' reactions to Bacon's 1949 exhibition, does not give names. However, Victor Pasmore was the pictorial and ideological antithesis to Bacon. Gowing was partly of Pasmore's milieu. Pasmore was born in 1908, the year before Bacon. He had exhibited with Bacon in 1936 when he was still making the observation-based figurative paintings he was to abandon in the late 1940s for abstraction. His first exhibition of entirely abstract paintings in 1951 made him a leading practitioner and advocate of non-figurative painting in England. Pasmore was a kind of Ruskinian. For Ruskin God's order was manifested in nature, and art must aspire to express that order. For Pasmore, rather than depict nature in tone, line and hue, artists should follow nature 'in the manner of its operation'. He derived his *Spiral Motif*, 1950 (fig.17), from mathematical studies of nature and growth.

17 Victor Pasmore
*Spiral Motif in Green,
Violet, Blue and Gold:
The Coast of the
Inland* 1950
Oil on canvas
81.3 × 100.3
(32 × 39½)
Tate

Pasmore tended to describe his work as guided by the logic of historical development. He abandoned figurative painting because 'the only field which appeared open to rational development was in terms of abstract form'. Pasmore saw art as progressive, as evolving like and with science. Bacon's discussion of modern art was couched in terms not of art's evolution but of what it is possible to do as a painter now: history as a condition rather than a process. Pasmore seems to hold that reason and nature are in ultimate harmony. In Bacon's work human consciousness and desire are alienated from the natural world. There are conflicting natures and they are not benign.

Looking at the series of heads Bacon exhibited in 1949, Pasmore must have seen Bacon as the voice of pictorial and ideological reaction. Before a dark curtain in black, greys and blue-brown – almost monochrome – *Head I* (fig.18), *II* and *V* show mouths wide open and ape-like, with long canine teeth exposed as if emitting some terrible animal cry. In *Head VI* (fig.19) the screaming mouth, teeth no longer ape-like, is a dark orifice above the purple-clad shoulders of the first of Bacon's pope paintings. It was derived from a reproduction of Velázquez's *Pope Innocent X*, 1650. The source for the open mouth is attributed to the mouths of two women, both at the moment before a child's death: the nurse shot on the Odessa steps in Eisenstein's *Battleship Potemkin* and the mother protesting at the murder of her infant in Nicolas Poussin's *The Massacre of the Innocents*, 1630–1.

The renegade Surrealist Georges Bataille referred to the mouth as the means by which human animals express moments of extreme emotional and physical feeling. The art-historian Dawn Ades has discussed Bacon, photographs of slaughterhouses published in *Documents* and the writings of Georges Bataille, who edited the magazine between 1929 and 1930. Bacon possessed copies of *Documents*. Bataille wrote: 'On great occasions human life is concentrated bestially in the mouth, anger makes one clench one's teeth, terror and atrocious suffering make the mouth the organ of tearing cries.'[3]

The artists' reaction to the 1949 exhibition reported by Gowing was not universal. Wyndham Lewis, 'that lonely old volcano of the Right' as George

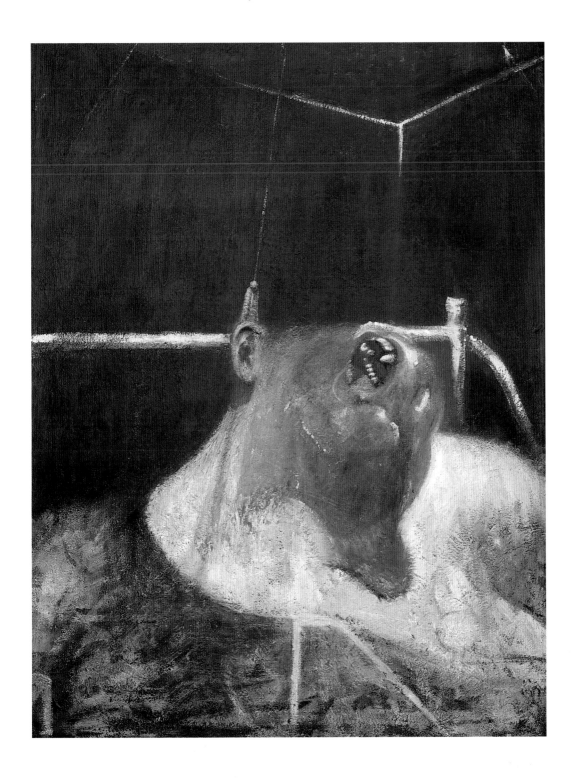

18 *Head I* 1948
Oil and tempera on board 100.3 × 74.9 (39½ × 29½)
Richard S. Zeisler Collection, New York

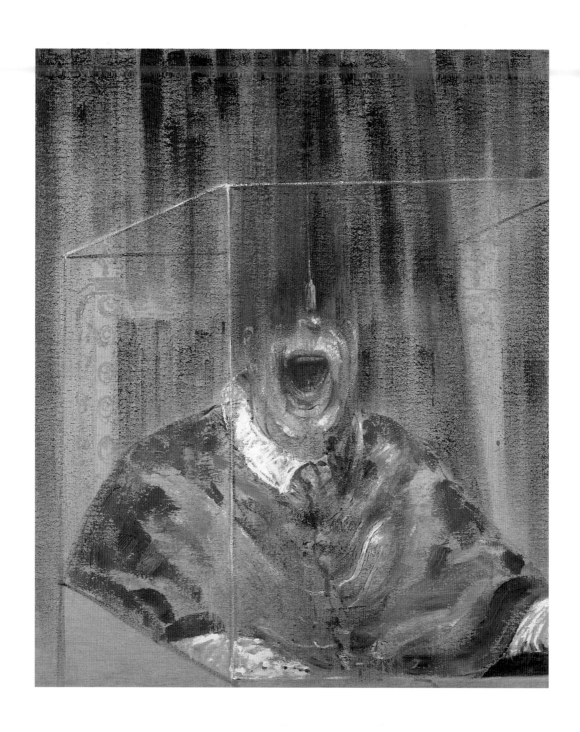

19 *Head VI* 1948
Oil on canvas 93 × 77 (36¼ × 30¼)
Hayward Gallery, London, Arts Council Collection

Orwell called him, was then eking out his income by writing art reviews for *The Listener*. Arguably, his work as a painter, novelist and theorist constitutes the most important and serious confrontation with modernity by any British artist in the first half of the century. Bacon's work in the second half of the century constitutes a similar achievement. Lewis wrote:

> Of the younger artists none actually paints as beautifully as Francis Bacon. I have seen painting of his that reminds me of Velásquez and like that master he is fond of blacks. Liquid whitish accents are delicately dropped upon the sable ground, like blobs of mucus – or else there is the cold white glitter of an eyeball, or of an eye distended with despairing insult behind a shouting mouth, distended also to hurl insults. Otherwise it is a baleful regard from the mask of a decaying clubman or business executive – so decayed that usually part of the head is rotting away into space. But black is his pictorial element. These faces come out of the blackness to glare or to shout.[4]

Lewis, who rarely wrote without attacking someone, had described Bacon's paintings in an earlier article, at the same time as taking a swipe at Munnings and the Royal Academy. He concluded, 'there are, after all, more things in heaven and earth than shiny horses or juicy satins. There are the *fleurs du mal* for instance.'

Painting, Photography, Portraits, 1951–9

> Actually, Michelangelo and Muybridge are mixed up in my mind together.[5]
>
> Francis Bacon, Interview 4, 1974

Bacon's next exhibition at the Hanover in December 1951 included his first portrait with a named subject, *Portrait of Lucian Freud*, 1951 (fig.20), derived from a photograph of Kafka. When Freud arrived to pose for Bacon, he found the portrait almost finished with a good likeness. Bacon said he only wanted to work on the feet, but did extensively rework it. Bacon did at times have the subjects of his portraits sit for him. Nevertheless, he would also work from photographs of them or of other things that informed the image he was making.

In 1951–2 Bacon worked in a studio at the Royal College of Art where the *Portrait of Lucian Freud* was painted. The artist Albert Herbert was a student at the time. He recalled in a letter:

> In 1951 John Minton inherited some money and went to Jamaica giving his teaching time to Francis Bacon. Professor Moynihan let Bacon use his studio to work in ... I first saw him in the student wash room, stripped to the waist, washing oil paint off his shoulders. I was too shy to comment on this, but at some point I did tell him that oil paint on raw canvas was supposed to rot it. He just shrugged and said 'Degas did it'. He was quite affable and smiley but made no attempt at all to do any teaching ... He was not secretive. He left the door of his

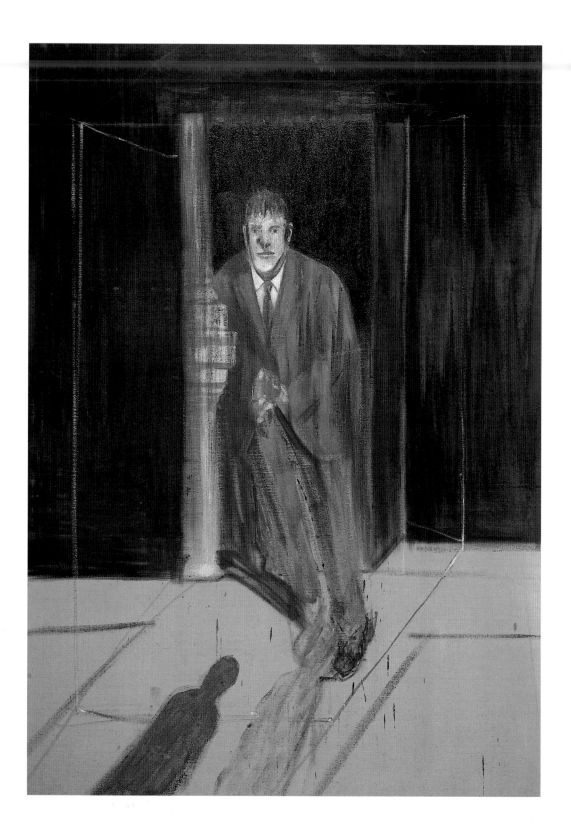

studio ajar and during his very long lunches I often went in to see what he was doing. There were about 20 canvases, perhaps about 4′ x 3′ stretched the wrong way round. At one time he filled a bucket with black house paint and with a broom from the corridor splashed it over the canvases. It also went over the walls and ceiling. I noticed that he drew on the canvases with chalk and pastel – working out compositional lines in the traditional way. These lines were eliminated when he painted over them. He was not quite so spontaneous as he later said. I am certain I remember this correctly because I copied the idea myself.[6]

Painted in the studio Bacon was to occupy, Rodrigo Moynihan's *Portrait Group*, 1951 (fig.21), depicts the staff of the Painting School of the Royal College of Art. It is reproduced here to illustrate not only the place and the people with whom Bacon had long lunches but also the contemporary traditionalist painting whose conventions Bacon's paintings were subverting. In some ways he was more academic than they were. He re-configured the conventions in his evolution from a technically limited painter to a virtuoso in his own pictorial dialect.

The activity of painting deploys skills that come from imitation and practice. Skill is tacit knowledge; capacities grounded in the training of habits of hand and eye rather than in explicit principles. How painters acquire and develop their skills is obviously a fundamental determinant of their work. English art school pedagogy and painting since Ruskin and the Pre-Raphaelites were predominantly linear. Line depicts what we know of the physical structure of things rather than what we see. By the end of the nineteenth century, drawing the nude model was at the core of art-school training in Britain. Bacon avoided this training in a skill rooted in delineating the inert body of the model day in day out for years.

Alternatively, by hue, tone and intensity the painterly approach shows what we see. It is closer to raw sight. In a brief statement in praise of the

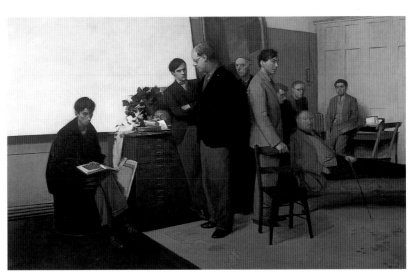

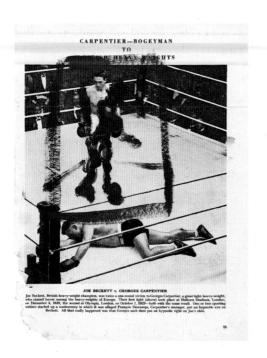

22 Georges Carpentier
'Carpentier-Bogeyman to British Heavy-weights:
'Joe Beckett v Georges Carpentier'
Loose leaf from unidentified book on boxing
Oil painting over illustrations
27.5 × 20.8 (10⅞ × 8⅛)
Tate

23 *Pink Crawling Figure c.*1957–61
Ballpoint pen and oil on paper
40 × 270 (13⅜ × 10⅜)
Tate

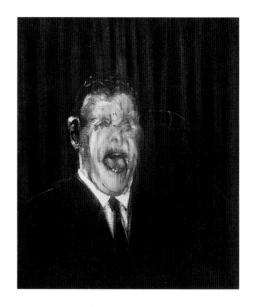

painter Sir Matthew Smith published in 1953, Bacon advocated a painterly method in which idea and technique were inseparable, in which the 'brush-stroke creates the form'. Every movement of the brush on the canvas should alter and shape the image. Paint should never 'merely fill in'. 'Francis said he couldn't draw,' reported the artist Richard Hamilton. 'Maybe what he meant was that he wasn't happy describing the three dimensional object with a line.'[7]

In practice, Bacon keeps both the linear and the painterly in contradictory play. His lines are various, from the ghosts of the initial black drawing to the white lines of the perspective space frames. Black lines might propose the edge of a form otherwise lost in paint. Broken and dotted white lines can evoke a highlight along an edge. In later paintings, he was to add to this vocabulary the un-drawn line of nearly raw canvas left between two abutting areas of paint, creating an active border.

Grounded in the use of photographs, Bacon's skill as an image-maker derived from depictions of bodies in motion. Before the rise of nineteenth-century realism copying the work of others and drawing from statues formed the basis of academic art training. Bacon learnt to draw from copying and working on lens-derived images. The revelation after his death of his works on paper confirms his debt to photography. He drew with a brush and scratched on photographs in a way that summarises posture and movement. In the photograph *Georges Carpentier* (fig.22) Bacon has created a rhythm of brush strokes down the body. In *Pink Crawling Figure* (fig.23) he uses the same explicit movement of the brush to express movement, here painted over a ballpoint-biro linear drawing.

There are many gestures, postures, facial expressions and bodily move-ments in Bacon's work that are rare in the work of other painters, even those who use photography. The quality of movement and expression in *Three Studies of a Human Head*, 1953 (fig.24), is outside the vocabulary of painting. I can-not think of any other paintings that capture these instant moments of facial

24 *Three Studies of a Human Head* 1953
Oil on canvas Each 61 × 51 (24 × 20)
Private Collection – courtesy Massimo Martino Fine Arts
& Projects, Mendrisio

41

movement. The draughtsmanship of the conventionally trained painter carries within it the immobile body, the limited vocabulary of positions and expressions of the inert and bored body of the art-school model.

Portrayals

At the core of twentieth-century English traditionalist painting was a pictorial grammar with rules about how form in space should be rendered. Such paintings do not just copy an appearance: they use form and perspective rather as if a landscape painter were to create a contour map beneath grass, bushes or other element of a work. A linear sense of volumetric form in space gives perspectival structure to highlights, gradations of tone and brush marks. It is the antithesis of photography. Photographs are mere mechanical indexes of light and dark upon a surface and lack structural foundation. Bacon's portraits of the early 1950s take this superficiality to an extreme: rather like the Turin Shroud, heads seem to be imprinted onto the canvas, and features onto be-suited bodies. At various times he would dab and rub paint on with a cloth, or he might spray, throw or splash it on. The character of his brush marks comes from different sizes of brush. Only occasionally does the movement of Bacon's marks indicate volumetric form. If a shape or structure is implied beneath the painting, it is not that of a linear drawing, but rather the gradations of light as rendered in black and white photography.

Commissioned portraiture was still the economic backbone of many traditionalist painters. In the annual Royal Academy exhibitions of the 1940s to 1960s portraits occupied swathes of wall space. Many of Bacon's paintings

25 *Portrait of R.J. Sainsbury* 1955
Oil on canvas
115 × 99 (45¼ × 39)
Robert and Lisa Sainsbury Collection, University of East Anglia, Norwich

were portraits. *Portrait of R.J. Sainsbury*, 1955 (fig.25), was commissioned by one of the dynasty of food retailers, who was a major patron of Bacon in the 1950s. One reason that Bacon did not disappear into portraiture in the manner of mainstream English painters was that he did not paint, as they did, as if cinema and photography had never happened.

Bacon continued to paint portraits for the rest of his life. They are some of his most accomplished works. In the period between the mid-1950s and the early 1960s, they are perhaps the best of his paintings. *Miss Muriel Belcher*, 1959 (fig.26), is one of the paintings where Bacon shifts the emphasis from movement of the human form to movement within the form. Painted into the still of a light green rectangle is an animated head. It is as if we are looking

26 *Miss Muriel Belcher* 1959
Oil on canvas
74 × 67.5
(29 × 26½)
Private Collection

down at someone sleeping on a mattress on the floor. Smears, broken strokes, paint scumbled or textured by dabbing with corduroy, all serve to set up a storm of features. The seemingly closed eyes and the still depths of the greens are the counterpoint to the erupting form. Miss Belcher started the Colony Club in Soho in 1948 with Bacon as a freeloading social attraction. With an endless procession of gin and tonics, she would perch at the end of the bar next to the door like a survivor from the Blitz. Bacon painted the portrait from memory when he was in St Ives for three months working for his first exhibition at Marlborough Fine Art.

Critical Politics in the 1950s

I'm not upset by the fact that people do suffer, because I think the suffering of people and the differences between people are what have made great art, and not egalitarianism.[8]

Francis Bacon, Interview 4, 1974

In the major art-critical battles fought by a brilliant generation of writers in Britain in the 1950s Bacon's work was a defining issue. John Berger and David Sylvester were two of the critics. Berger wrote regularly and Sylvester periodically for the influential left-wing *New Statesman*. Mary MacCarthy has pointed out that subscribers to *Readers Digest* were better informed about the Gulag and the atrocities of Stalinism than were readers of the *New Statesman*. Berger's politics were close to the pro-Soviet communist party, but he was not a member. In his brand of socialist realism with a human face art should serve the struggle for social justice. David Sylvester, however, was concerned with describing the experience offered by a work and its devices, and locating them within art itself, rather than seeing it as an instrument of social and political progress. In 'Curriculum Vitae', the introduction to his collected essays, *About Modern Art: Critical Essays 1948–97*, Sylvester recalls realising at the end of the 1940s that Bacon's work was 'painting, not a cry of pain'.

In the search for figurative art that was new and grand it was important not to be confused by all the retrogressive attempts which a host of painters and sculptors everywhere were making 'to go back to the figure'. Such efforts were insistently promoted by the most influential critic on the scene, John Berger, whose primary heroes were Guttoso, de Staël and Friso ten Holt. It was not surprising that Berger failed to recognise Bacon: he was too much of a boy scout not to see Bacon as a monster of depravity.[9]

Berger wrote about Bacon in the early 1950s. He renewed his critique in an essay 'The Worst Is Not Yet' in 1972, a revised version of which, 'Francis Bacon and Walt Disney', was published in 1980 in *About Looking*, an anthology of essays. In this essay he does acknowledge Bacon's achievement, saying 'there has never been painting quite like this'. He refers to his 'mastery', 'his extraordinary skill', 'dedication' and 'lucidity'. He charges Bacon, nevertheless, with being a conformist by acquiescing in the inhumane alienation of

modern society: Bacon depicts alienated behaviour and interprets it 'in terms of the worst possible having already happened, and so proposes that both refusal and hope are pointless'. Berger concludes that Bacon's work makes no comment on social relations, on bureaucracy, industrial society or the history of the twentieth century; his work is a demonstration, rather than an expression, of a desire for mindlessness, for absolute alienation.[10]

Berger's argument has insights. It is, however, factually wrong in as much as Bacon's imagery does have origins in the history of the twentieth century in a way that is more calculated than a mere symptom of alienation. Bacon, however, did not make public the paintings that evidence this.

In 1951 Bacon left his studio in Cromwell Place, South Kensington, which was very close to the Victoria and Albert Museum and the painting school of the Royal College of Art. He sold the lease on to the portrait painter Robert Buhler, who taught at the RCA and was included in Moynihan's *Portrait Group* (fig.21). He found seven abandoned canvases in the studio and sold them; among these was *Man in a Cap*, 1941–2 (fig.27). The head in *Man in a Cap* resembles that of the shouting Dr Goebbels recorded in Sam Hunter's photograph of images in Bacon's studio (fig.15). It is one of a million other photographs and films of shouting leaders addressing Nazi and Fascist rallies that invaded the newspapers and newsreels of the 1930s. The body leans its weight onto a rail, and the head is askew of and somehow detached from the anatomical logic of the body, a device that Bacon was to use many times in the future. From the source and context of the photograph we know that the mouth is shouting not screaming, but the physiognomy of the mouth is such that rage,

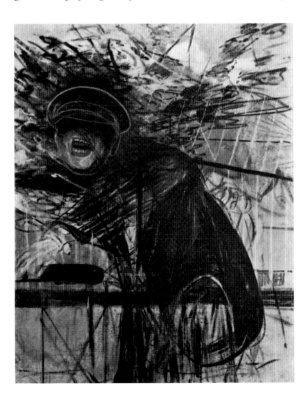

27 *Man in a Cap*
1941–2
Oil on composition
board
94 × 73.5 (37 × 29)

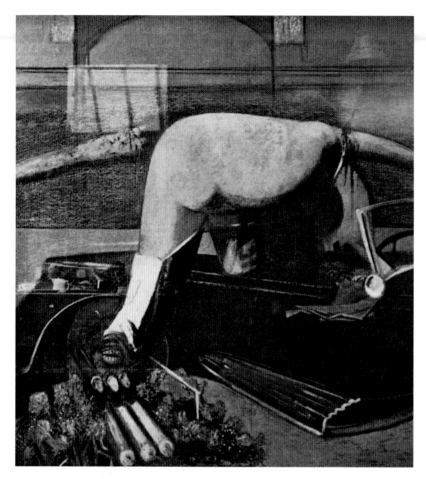

28 *Figure Getting out
of a Car c.*1943
Photograph of First
State of *Landscape
with a Car c.*1939–40
Oil on canvas
144.8 × 128.3
(57 × 50½)

ecstasy and harangue are indistinguishable in appearance. Bacon's popes are shouting at least as much as they are screaming.

In 1946 a visitor to his studio photographed a painting made around 1939–40 that Bacon was subsequently to revise radically (fig.28). The photograph catches an illuminated window and a tray of tea things reflected in the glass of the glazed painting. The origin of the image, Bacon told Ronald Alley, was a photograph of Hitler getting out of a car at one of the Nuremberg rallies.[11] The huge biomorphic monster thrusts its long neck into a bouquet of microphones and flowers. The monster has precedents in both Bacon's earlier work and that of his mentor of the early 1930s, Roy de Maistre. The labial mouth and its exposed teeth reappear in the central panel of *Three Studies for Figures at the Base of a Crucifixion*, 1944 (fig.29).

The ghost of a mouth shouting into a microphone can be found in the black that spreads from the open jacket in *Figure in a Landscape*, 1945 (fig.30). Its position presupposes the long neck of the biomorphic monster. A snapshot of Bacon's lover and supporter of the 1930s and 1940s, Eric Hall, dozing in a chair in Hyde Park was the initial source of the painting.

Sigmund Freud used 'over-determined' to describe a symptom, dream image or any other item of behaviour that had more than one meaning or

29 *Three Studies for Figures at the Base of a Crucifixion* 1944 (detail)
Oil and pastel on hardboard
Central panel 94 × 78 (37 × 29) Tate

expressed drives and conflicts derived from more than one level or aspect of personality. Bacon channelled into his painting potential meanings as diverse as his pictorial sources. In this sense they are over-determined contrivances. Expressive of images of political power in the twentieth century, the harangue physiognomy continues to figure in his work long after reference to its origin has disappeared. Power as libidinal energy animates Bacon's figures: they are driven by 'some primal, mysterious, sanguinary, self-immolatory craving', to quote again from Isaiah Berlin on Joseph de Maistre.[12]

Berger, in effect, regrets that Bacon has not constructed his practice within ideas of 'social relations', 'bureaucracy', 'industrial society', etc. This is the vocabulary of a would-be benign, progressive socio-political overview, the discourse of rational political management. Bacon's politics, that is to say his view of power, do not operate within these terms and the historical perspective of progressive intellectuals. Bacon may have become an intellectual, but he had none of their tendency to see themselves and their forms of thought and expertise as having some socially redemptive role.

For Bacon the ahistorical body *in extremis* is the essential actuality in a meaningless world. His sources of conviction are the antithesis to progressive

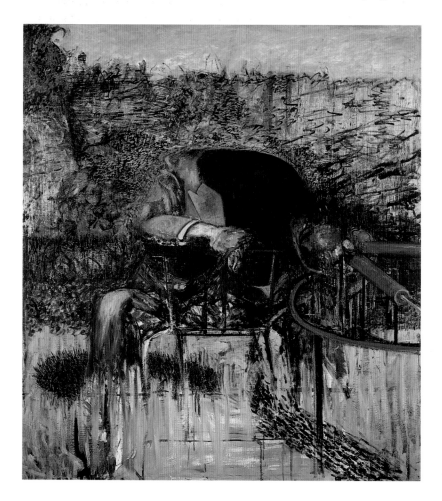

30 *Figure in a Landscape* 1945
Oil on canvas
144.8 × 128.3
(57 × 50½)
Tate

political overviews. Berger is right in that Bacon's work is not a journey into a world of social hope with its critiques of the present: it is a journey into an art of darkness. In this respect Berger's description does have insight, but Bacon does not acquiesce in alienation: he asserts it as the brutal and energising primal fact of life.

Bacon's Modernism and Pictorial Syntax

> One of the reasons why I don't like abstract painting, or why it doesn't interest me, is that I think painting is a duality, and that abstract painting is entirely an aesthetic thing.[13]
>
> Francis Bacon, Interview 2, 1966

Bacon's paintings are unlike the work of the artists thought to be closest to him. In an essay in 1975 the painter R.B. Kitaj coined the phrase 'The School of London', which has come to refer, in particular, to Bacon, Kitaj, Frank Auerbach, Leon Kossoff, Michael Andrews and Lucian Freud, Bacon's one-time friend and ideologically closest companion among these painters.[14] In Freud's work there is a linear and isolating separation of figures from context, even in his later apparently painterly work (fig.31). As in Bacon's paintings, light and dark do not meld together to form a shared pictorial space. Only Kitaj has Bacon's diversity of pictorial sources (fig.32). Nevertheless, neither the appearance nor the motivation of work by Kitaj, Freud and the other cited painters could be mistaken for Bacon's. Apart from anything else, they all, even Freud, retain the grammar of art-school draughtsmanship in their work.

In the 1975 essay Kitaj argued that an international style was denying just recognition to a school of major figurative painters working in London. Abstract painting, centred on New York, dominated critical and curatorial attention. Clement Greenberg was the most influential theorist and writer of the tendency. Born in New York in 1909, the same year as Bacon, Greenberg provides a point for beginning to locate Bacon's work within the broader terrain of modernist painting and aesthetics.

Mere fashion gives value to paintings that do not manifest anything other than the painter's aesthetic sensations. This was Bacon's dismissive argument about non-figurative painting. In contrast, Greenberg argued that the common characteristic of the most compelling modern art is that it addresses aesthetic sensations particular to its physical medium. Modern painting is about painting to the exclusion of all else, and its highest achievements are predominantly in non-figurative painting.[15]

In Greenberg's terms Bacon was not a modernist. He recognised Bacon's technical debt to academic painting, when he observed that Bacon was attempting to make art in the grand manner. In a 1968 interview Greenberg said:

> I go for his things at the same time that I see through and around them. It's as though I can watch him putting his pictures together ... I behold the cheapest, coarsest, least felt application of paint matter I can visualize, along with the most transparent, up-to-date devices ...

Bacon is the one example in our time of *inspired* safe taste – taste that's inspired in the way in which it searches out the most up-to-date of your 'rehearsed responses.' Some day, if I live long enough, I'll look back on Bacon's art as a precious curiosity of our period.[16]

Greenberg's notion of modernism reconciles art to the tradition of progressive post-enlightenment thought. He saw Kant as the first modernist thinker and aesthetician. While Greenberg does not argue for aesthetic progress, he does argue for the progress of aesthetics. Even if past judgements of what was of aesthetic value were often right, modern criticism has, science-like, refuted the grounds given for such opinions. Modernist sensibility arises out of the character of modern thought, out of its ever stricter and narrower requirement for 'the empirical and the positive'. The unified picture plane offers this as an aesthetic experience. It presents aesthetic vivacity without denying the painting's material reality as a flat surface, and it was the essential characteristic of what Greenberg called 'Modernist Painting'.[17]

Bacon's work enacts a different tradition formed in reaction to progressive enlightenment. A ruptured picture plane is the most constant factor in his painting. One part of the painting differs from other parts; there are simultaneously different kinds of pictorial language. Bacon creates explosions of space and movement in and out, across and at angles to the painting's surface, as in *Portrait of Isabel Rawsthorne*, 1966 (fig. 33). Out of a still darkness an outbreak of painterly marks forms a head and shoulders animated by highlights,

Below left
31 Lucian Freud
Francis Bacon 1952
Oil on metal
Support 17.8 × 12.7
(7 × 5)
Tate

Below right
32 R.B. Kitaj
Synchrony with F B – General of Hot Desire
1968
Oil on canvas
Right-hand panel of two, each
152.4 × 91.5
(60 × 36)
Mr and Mrs Ian Stoutzker, London

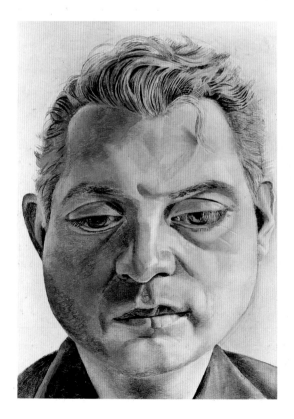

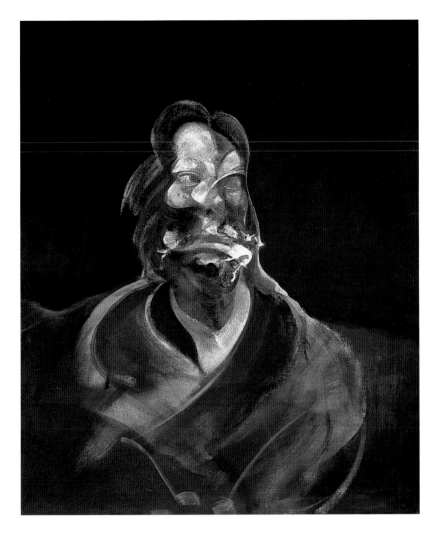

33 *Portrait of Isabel*
Rawsthorne 1966
Oil on canvas
81.3 × 68.6
(32 × 27)
Tate

dabs of textured paint, splashes of white, transparent strokes over the raw
canvas, residual drawing lines and the glance of her right eye. Against this
flurry of movement across and arching out of the canvas, is the stillness of the
mouth, the closed left eye and the dark.

Bacon chose to have his paintings glazed, and because of the reflections
and mirroring of the glass, it is almost impossible to take in his pictures as a
whole. We know the paintings in their entirety from suppressing these effects
in our mind's eye and from seeing them in reproduction. (Reproductions sup-
press disunity in the homogeneity of printer's ink. For instance, a thin indica-
tive brush stroke across raw canvas gains a decisive and integrated plasticity.)
Yet, with their energies contained within the great gold frames and the glass,
the paintings do offer a kind of totality.

The paintings have their roots in a tradition of modernism other than that
outlined by Greenberg. 'The ontological view governing the image of man in
the work of leading modernist writers,' according to the Marxist literary crit-
ic Georg Lukács, is that 'man is by nature solitary, asocial, unable to enter into

relationships with other human beings.'[18] Lukács's critique of literary modernism includes discussion of Franz Kafka, James Joyce, Marcel Proust and Samuel Beckett, and refers to T.S. Eliot: all authors whom Bacon read. The bulk of Bacon's paintings depict single figures, a characteristic that is most striking in the distribution of figures between the three separate canvases of the triptychs. When there is more than one figure in the same canvas they do not share a common space. There are exceptions, the most constant being figures merged in the act of sex: in the primal act they do share pictorial space (fig.34).

Bacon has more in common with and is more indebted to literary modernism than to the pictorial tradition included in Greenberg's account. Greenberg's modernism has its origins in the positive assertion of modernity, in what were often pictorial devices prompted by social and spiritual aspirations, as articulated in the Impressionists' dissolving of weight and abolition of tonal modelling, in the declared materiality and shallow pictorial space of Synthetic Cubism, and in the visual purity and non-figured paintings of Mondrian. These painters painted onto white primed canvas, while Bacon's stock-in-trade was the mid-toned canvas, used to evoke weight, darkness, depth and the human form; his is the pictorial rhetoric of despair.

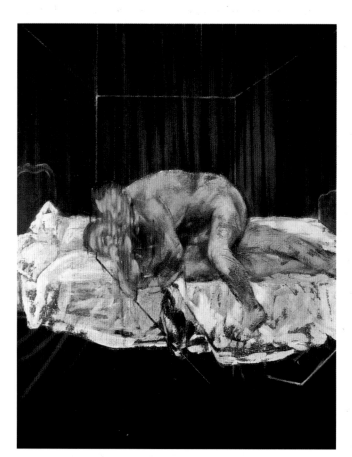

Left
34 *Two Figures* 1953
Oil on canvas
152.5 × 116.5
(60 × 45⅞)
Private Collection

Below
35 Eadweard
Muybridge
Athletes Wrestling
1887
Photograph
The New York Public
Library

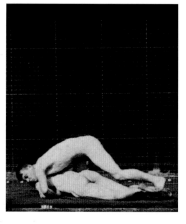

4

CRUCIFIXIONS

David Sylvester: In painting a Crucifixion, do you find you approach
the problem in a radically different way from when working on other
subjects?
Francis Bacon: Well, of course, you're working then about your own
feelings and sensations, really. You might say it's almost nearer to a
self portrait. You are working on all sorts of very private feelings about
behaviour and about the way life is.[1]

Interview 2, May 1966

Bacon's crucifixions are among his most important but not necessarily his
most accomplished paintings. They are important and yet less realised
because they are often the sites of renegotiations of what he is doing. The
repetition of the crucifixion exemplifies one of the characteristics of Bacon's
oeuvre, his reworking of motifs. For instance, the series of paintings of popes
replays the same basic image with limited variations and additions. However,
revisiting the crucifixions could also occasion a fundamental reconsideration,
calling into being both new motifs and developments, and setting new techni-
cal and aesthetic problems.

Painting, 1946

Painting, 1946 (fig. 36), is a crucifixion but not named as such. It continues the
theme of execution, and compared to the crucifixions of the 1930s, it has
gained in complexity and pictorial force. It retains traces of the images of
Hitler and other leading Nazis, particularly those showing these men on railed
podia surrounded by microphones and in open-mouthed harangue. Rails and
other confining or space-defining devices reappear in many subsequent
works. While the perspective cues within each of Bacon's pictures are mutu-
ally contradictory, his figures and other perspectival clues do predominantly
locate the viewer's eye-level about halfway down the painting. We look up at
the action in the imaginative space of the painting. For the rest of his working
life Bacon returns repeatedly to figures on podia, beds and platforms, like
altars raised up from the ground, a continuation into pictorial space of the
floor upon which the viewer stands.

In *Painting*, 1946, a crucified body hangs like an animal carcass behind the
black-robed figure of the open-mouthed executioner. In *Documents* Bataille
published photographs of a slaughterhouse, accompanied by a discussion in
which he connects religious sacrifice and butchery. The thrust of the text,
reports Dawn Ades, is an exposure of the hypocritical and hygienic life of
modern man that hides abattoirs from our sight, 'a sign of our inability, in

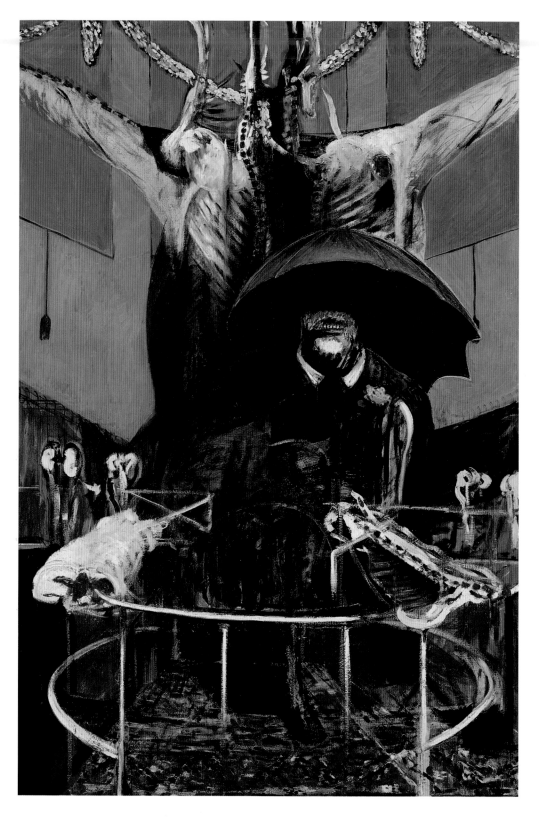

36 *Painting* 1946
Oil and pastel on
linen
197.8 × 132.1
(65⅞ × 52)
The Museum of
Modern Art, New
York; Purchase

Bataille's view, to tolerate our own ugliness',[2] and in Bacon's words, to face the 'brutality of fact'.

Fragments of a Crucifixion, 1950, and the Furies

The next-named crucifixion, *Fragments of a Crucifixion*, 1950 (fig.37), is a very different and atypical work. Rather than pushing events to the pictorial foreground or mid-ground, the cross is thrust to the literal surface of the painting. The background is a strip of sea and coastline with matchstick figures and cars. Shadowed by companions on either side, a be-toothed wide-open mouth within a proportionately small head and a yet proportionately smaller body with female pudenda is flapping before the cross. These strange figures are the forebears of the form the Furies take in later paintings.

Bacon refers to the Furies as the Eumenides, the kindly ones, a name given by the Athenians to assuage them. The Furies were the avengers of murder and crime against the ties of kinship; they were the personifications of guilt driving their victims to madness. Bacon's depiction of the Furies in *Fragments of a Crucifixion* is closer to the ancient Greek poet Hesiod's description than the form they took in *Three Figures at the Base of a Crucifixion.* Hesiod describes them as three winged women with snakes about them. Above them in the painting a dog-like creature is draped down from the cross bar.

Fragments of a Crucifixion is, as I have said, atypical. Features of its rawness predict the form of the Furies that were to revisit Bacon's paintings particularly after the death of his lover George Dyer, for example in *Three Figures and Portrait,* 1975 (fig.38). A black-and-white photo-like portrait of Dyer looks down at two convulsing figures in an arena defined by a fractured circular band that moves from flat yellow to shaded rotundity. The figure on the left has the head of Dyer. The spine emerges from its back, an idea derived from Bacon's misreading of a drawing by Degas, *After the Bath, Woman Drying Herself,* 1903 (fig.39). Bacon read the roll of flesh and muscle pushed up by the position of the model's scapula as the spine. 'The spine almost comes out of the skin altogether,' he said in 1966. The right-hand figure turns away from the images of Dyer and the viewer. Perched on a box frame in the foreground sits a Fury or perhaps another classical Greek monster, a harpy. Harpies were the souls of the dead in the form of birds with a woman's face that snatched the souls of the living. Here the harpy has a fleshy body like an amalgam of buttocks and chickens' thighs with sketchily indicated birds' legs, and a mouth that goes back to the central figure of *Three Studies for Figures at the Base of a Crucifixion,* 1944 (fig.29).

Three Studies for a Crucifixion, 1962

Completed just before his first retrospective at the Tate Gallery in 1962, Bacon's next crucifixion, *Three Studies for a Crucifixion,* 1962 (fig.40), is again an important and predictive transitional work. It was the beginning of the many large and identically sized triptychs he was to make for the rest of his life. David Sylvester in his review of the Tate exhibition for the *New Statesman*

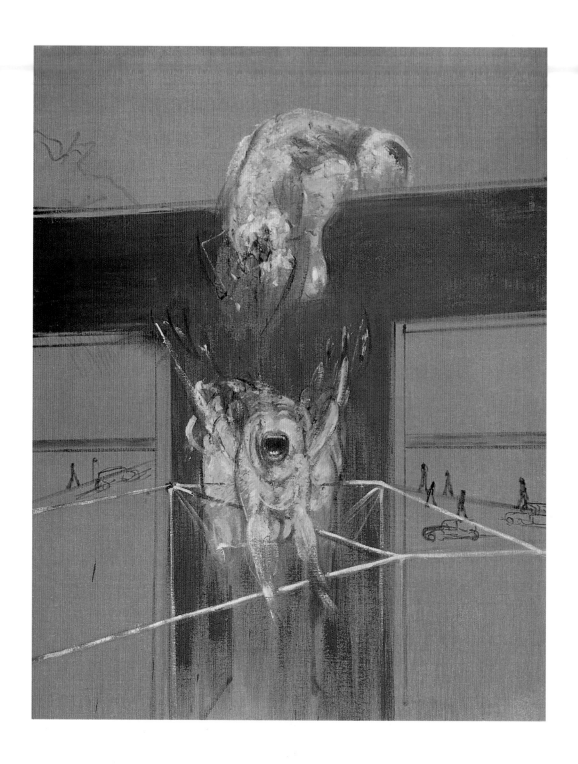

37 *Fragments of a Crucifixion* 1950
Oil and cotton wool on canvas
140 × 108.5 (55 × 42¾)
Stedelijk van Abbemuseum, Eindhoven, Netherlands

38 *Three Figures and
Portrait* 1975
Oil and pastel on
canvas
198 × 147.5
(78 × 58)
Tate

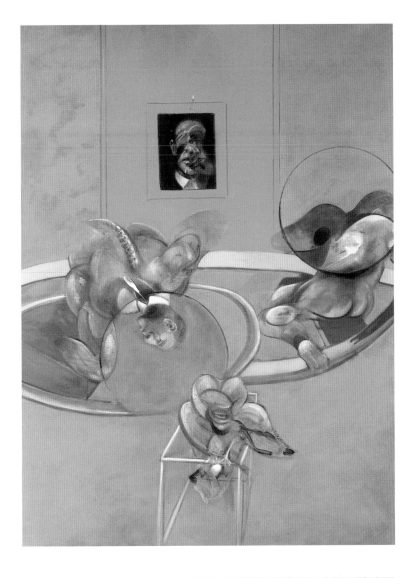

39 Degas
*After the Bath,
Woman Drying
Herself* 1903
Oil on canvas
69.9 × 73
(55 × 28¾)
National Gallery,
London

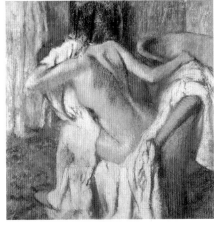

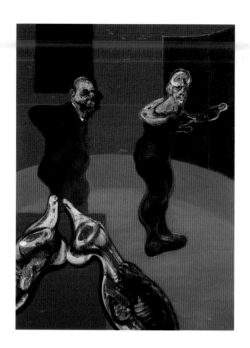
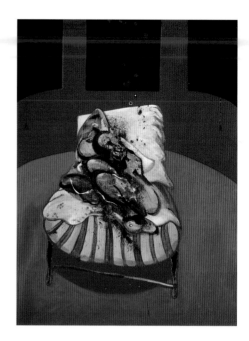

argued that since 1957 Bacon had changed from 'treating the canvas as a tank into treating it as a surface'.[3]

Sylvester's reference to 1957 points to the paintings that were inaugurated by a series of canvases based on Van Gogh's destroyed *Painter on the Road to Tarascon*, 1888, and painted for Bacon's last major exhibition at the Hanover Gallery. In these paintings tone was subordinate to colour. Previously light and dark had described depth and rotundity, and colour provided incident or emphasis within the tank of darkness. In the Van Gogh paintings, rather than describe bodily movement, intense hues laid over each other in explicit brush strokes created a rhythm across the canvas, emphasising the surface of the painting. Bacon was coming to terms not only with Van Gogh: in the wake of American Abstract Expressionism, artists in London were reconsidering colour, paint handling and scale. London had had its first major glimpse of this work in a CIA-backed Museum of Modern Art touring exhibition shown at the Tate Gallery in 1956.

Sylvester went on to observe, in his 1962 review, that in the post-1957 work the masses were not linked to the surrounding space. The figure painted onto a separate piece of canvas and then stuck on the main canvas in *Reclining Woman*, 1961 (fig.41), makes the point. Furthermore, there is little painterly articulation of the body, which remains a blob of confused and uninteresting hues. Sylvester concludes that in *Three Studies for a Crucifixion*: 'It looks here as if Bacon has been trying to reconcile the compact sculptural character of the forms of his 1944 triptych ... with the more painterly and "realistic" handling of the subsequent work. The space still doesn't entirely convince, but the impact is electrifying all the same.'[4]

Given that the three-canvas format might suggest a story, Bacon was

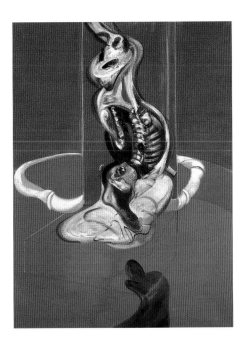

40 *Three Studies for a Crucifixion* 1962
Oil with sand on canvas
Three panels each 198.2 × 144.8 (78 × 57),
overall 198.2 × 434.3 (78 × 171)
Solomon R. Guggenheim Museum, New York

clearly anxious in his comments on the triptych to declare that this was not a narrative. It had been produced under exceptional circumstances over two weeks and he had worked either drunk or severely hung-over, he told David Sylvester in an interview.[5] At times, he did not know what he was doing. He specifically denied any rational explanation for the figures on the left.

However, Michael Peppiatt has offered a biographical reading of the painting. He sees the left-hand panel as depicting Bacon's father and Bacon himself in a body stocking or tights with a hint of women's garters and underclothes beneath. It is the moment of Bacon's expulsion from home. In the centre canvas Peppiatt recognises the bed as Bacon's bed from Morocco upon which he received many beatings from his lover Peter Lacey and others as part of masochistic sex. At the time of painting Lacey was dying in Morocco. The inverted figure on the right, Bacon revealed, came from a crucifix by the thirteenth-century Florentine painter Cimabue that suggested to him a worm crawling down the cross. Peppiatt sees this as an example of the sublimation of personal pain in a universal symbol.[6]

Peppiatt is probably right to see the work as autobiographical. The painting has the rawness of a transitional work, transitional not only in the formal sense that Sylvester argued but also in the use of autobiographical incidents as a source. The painting's failure arises from the forcing of this new content. The two figures on the left hang indecisively in the space of the picture. The central figure has areas of animated painting, but in its disorder it becomes illustrative. Paint ceases to describe movement, becoming unambiguously blood, torn flesh and exposed teeth. The lack of clarity of much of the right-hand figure seems arbitrary within the easily recognised horror. It lacks painterly life, it fails to create form.

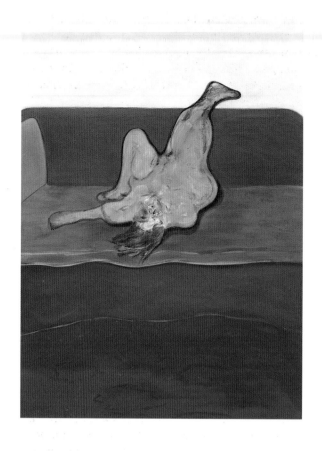

41 *Reclining Woman*
1961
Oil on canvas
198.5 × 141.5
(78¼ × 55¾)
Tate

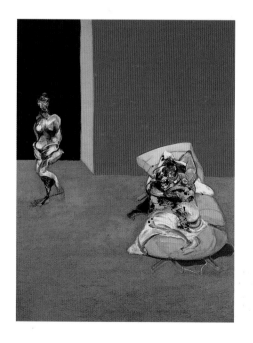

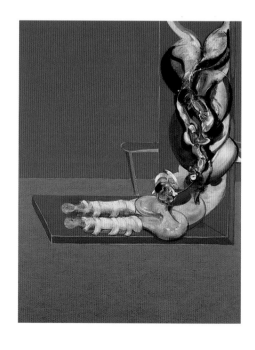

This biographical reading does imply that Bacon hid the origins of the work's imagery. It also suggests that the painting is an announcement of enraged grief or, less sympathetically, dramatised self-pity. The picture is a massed assault by hue, imagery and title. With no cross the Christian connotations come from Bacon's choice of title. There is blasphemy in the snarl of the ape-like teeth of the inverted body derived from an image of Christ. As the last painting in his first retrospective in the Tate Gallery, there could hardly be a more offensive image. This painting, or at least its reference to Cimabue, provoked the renegade Christian art critic Peter Fuller (1947–1990) to describe Bacon as an 'evil genius' and to condemn his vision of humankind as 'odious'.[7]

Autobiography and *Crucifixion*, 1965

Bacon was to return to similar motifs two years later in another triptych, *Crucifixion*, 1965 (fig.42). Apart from the new version of *Three Studies for Figures at the Base of a Crucifixion* produced in 1988, it was the last painting he was to call a crucifixion. Again there is the mangled figure on the bed, this time in the left canvas and observed at a distance by naked women. Is this a return to autobiography, but with the mother's indifference as the personal wound? In her deformities she is the pictorial sister of the female figure in *After Muybridge – Study of the Human Figure in Motion – Woman Emptying a Bowl of Water/Paralytic Child Walking on all Fours* (fig.3). This was painted in the same year, and I have already suggested that the painting has an autobiographical source. Again the opened-up and up-turned figure, this time in the middle panel, with bound arms and within its entrails the suggestion of a bird, which in later paintings converges with the depiction of the Furies. On the right two men in

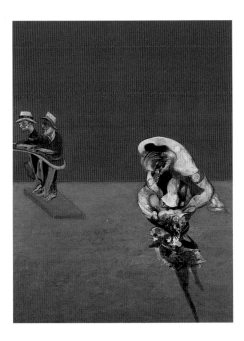

42 *Crucifixion* 1965
Oil on canvas
192.2 × 147 (77 × 57⅞)
Loan of Pinakotheks-Verein at the Bayerische
Staatsgemäldesammlungen Munich

Panama hats are leaning against some surface that could be anything from racetrack fencing to a bar. Moreover, in the foreground a figure described by Michel Leiris, the French writer and friend of Bacon, as 'a man, scarcely visible except for his tricolour cockade, is being molested by someone wearing a swastika armband'.[8] Given the position of the dominated figure and the dash of red there is a suggestion of bloody fellatio. In this reading the figure is an explicit image of an implicit theme that runs through Bacon's work: the eroticism of sex, violence and political power.

In one of his interviews David Sylvester reported to Bacon that people thought the figure was either a Nazi or the character dressed as a Nazi in Genet's play *The Balcony*.[9] He suggested this was an example of people making a narrative interpretation. Bacon said he disliked such interpretations. The swastika had no motive other than a need for a patch of red. Nevertheless, there is another narrative cue or link. Both the figure on the bed and the figure Leiris describes on the right have tricolour cockades.

What function in Bacon's paintings does autobiography serve? The relative failure but importance of the 1962 and 1965 triptychs are attributable to Bacon beginning to explore autobiographical incidents as a source. In the more successful paintings, such as the later triptychs concerned with George Dyer's death, autobiography is a means of achieving a complex painting; it is not a story that explains the painting. In the search for the compelling image it is one of many conflicting intentions brought to bear. In making paintings there is a moment when the painting can start to achieve its own internal vivacity, when the elements brought into being on the canvas start to gain a life beyond whatever prompted them initially. However, just as a good argument prompted by anger can be spoilt by a compulsion to abuse, so the initial motive for an image can be too compelling and overwhelm its potential, as in *Three Studies for a Crucifixion*.

Three Studies for a Crucifixion, 1962, and *Crucifixion*, 1965, like *Painting*, 1946, and *Fragments of a Crucifixion*, 1950, were the forcing houses of new content. They made new technical demands that later paintings were to meet. They were, nevertheless, some of Bacon's most important paintings. To return to scenes of human sacrifice was to revisit a core motif in, and motivation for, his work. But in reviving the crucifixion motif, he came close to the sin of illustration.

5

ILLUSTRATION, DELEUZE
AND THE DYER TRIPTYCHS

> I think in our previous discussions, when we've talked about the possibility of making appearance out of something which is not illustration, I've over-talked about it. Because, in spite of theoretically longing for the image to be made of irrational marks, inevitably illustration has to come into it.[1]
>
> <div align="right">Francis Bacon, Interview 5, 1975</div>

Illustration is a keystone term in the structure of Bacon's discussion of his own work. From his earliest to last statements, he used it repeatedly to indicate what his work was not. His idea of what he was doing revolved around distinguishing it from illustration. In citing illustration as the antithesis to art he was not alone, Clement Greenberg also referred to it in this way and, as we will see, so did one of Bacon's most distinguished interpreters, the French philosopher Giles Deleuze.

For Greenberg illustration accompanies another term of disparagement relevant to Bacon: 'literary'. Whereas, for instance, Bacon admired Picasso's work when he was close to the Surrealists, between 1926 and 1932, for Greenberg this was when Picasso lost his way in 'illustrative expressionism'. In *The Three Dancers*, 1925 (fig.12), the painting in which Picasso announced his semi-detached alignment with the Surrealists and to which I have already referred as a source for Bacon, Picasso becomes illustrative and literary, argues Greenberg.

> Now illustration addresses nature, not in order to make art say something through nature, but in order to make nature itself say something – and say it loudly. Yet the *Three Dancers* goes wrong, not just because it is literary (which is what making nature speak through art comes to), but because the theatrical placing and rendering of the head and arms of the centre figure cause the upper half of the picture to wobble. (Literature as such has never yet hurt a work of pictorial art; it is only literary *forcing* that does that.)[2]

Seen in these terms, Bacon's work is illustration. It does make nature, often horrifically fractured, speak through art and loudly. What then did Bacon mean by illustration?

Bacon seems to have thought that illustration comes in two forms: images that are subordinate to a text, i.e. they illustrate words; and images that merely imitate appearances. He gives an example of the latter when he claims that for him photography is always illustration. The clearest example he gives

43 Rembrandt
*Self-Portrait c.*1659
Oil on canvas
30 × 24 (11¾ × 9¾)
Musée Granet,
Aix en Provence

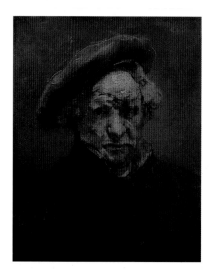

44 Graham
Sutherland
Somerset Maugham
1949
Oil on canvas
Support
137.2 × 63.5
(54 × 25)
Tate

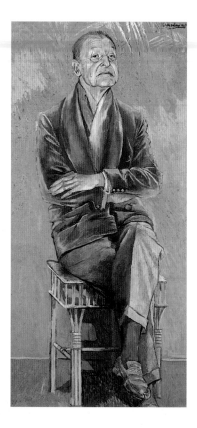

of not-illustration is a disputed Rembrandt, *Self-Portrait, c.*1659 (fig.43). 'There is a coagulation of non-representational marks which have led to making up this very great image,' said Bacon. A counter-example of a merely representational painting might be the later work of Graham Sutherland (fig.44), which Bacon, in a final break with his former supporter and friend, likened to a *Time* magazine cover. What such paintings fail to do, in Bacon's terms, is to have a direct effect upon the viewer's 'nervous system'.

Deleuze

It is around Bacon's distinction between illustration and paintings as art that the French philosopher Giles Deleuze (1925–95) in his book *Francis Bacon: Logique de la Sensation*, 1981, conducts his discussion of Bacon's paintings.[3] For Deleuze philosophy is the activity of forming, inventing and fabricating concepts, while the object of art is the forming, inventing and fabricating of aggregates of sensations. Within their different domains both are concerned with the new, with provoking thought. Bacon figures in his theory of sensations (aesthetics) as part of his critique and recasting of Kant's philosophy. According to Deleuze, Kant presupposes a 'common sense' that unites all the faculties; all the capacities of mind have a common core. Aesthetic experience is a particular configuration of the faculties and reasoning is another. These and other exercises of mental capacities unite in a common sense. Deleuze

argues against this common sense and for the independent logic of the faculties.

Recognition of something in the world, e.g. that a particular object is a tree, is an 'act of accord' of this common sense of the faculties and has been held as a model of understanding by Kant and the tradition of philosophy. The presupposition of a given common sense in the very nature of thinking is for Deleuze dogmatism, it denies the particularity of different faculties. It assumes the unity of the mind. Deleuze equates recognition with Bacon's idea of illustration. He distinguishes between the *figurative* (illustration, narrative), which triggers recognition, and the *figural*, where a figure is constituted in the experience of the painting. Art is properly figural not figurative: 'Sensation is what is painted in painting. It is the body, but not in the sense that body is represented as an object; rather in the sense that the body is experienced as experiencing such sensations.'[4] In other words, in a painting we should *experience* the sensation of a figured body rather than *recognise* the sensation of a depicted, figurative body. This leads Deleuze to argue that Bacon's paintings enact the logic of sensation.

Deleuze offers a systematic distinction between painting as art (the figural) and illustration (the figurative) by seeing Bacon's work as essentially painterly sensation. However, it asks us to ignore elements in Bacon's work that are dependent on figurative recognition, such as the directional force of a figure's glance or the recognisable face of a person. More broadly, it denies the linear, which works with the recognition of things rather than the optical sensation of the painterly. These are core characteristics of Bacon's paintings, which function by their non-resolution of illustration and painting as art.

In their non-resolution Bacon's paintings are an incitement to interpretation. It is a mistake to accept Bacon's denials of linguistic sources and intent. As Paul Valéry, one of the authors he admired, argued, 'all the arts live by words. May not the prime motive of any work be the wish to give rise to discussion, if only between the mind and itself?'[5] The operative word here is discussion, which implies an exchange without conclusion. Contrived as an incitement to words, Bacon's images call for and refuse description. As Ernst van Alphen shows in the first chapter of his book, *Francis Bacon and the Loss of Self,* 'his works cancel out, as well as stimulate narrative readings'.[6]

The Dyer Triptychs

How does the left panel from *Triptych 1971* (fig.45) work as both incitement and resistance to words? On a great flat pink plane at about eye level there is an eruption of smeared and brushed paint, a figure crouched or fallen on what could be a shelf or bench (possibly a cushioned bar bench); either his shin is missing or it disappears into the cushion. The 'or' and 'could be' are vital, for in them lies the virulence of the image. The figure is a suggestive mess of internal contradictions. It grabs the attention like a guilty glimpse of a human freak or a bloody accident. Dressed like a boxer, the figure has one foot bootless. The left arm sweeps into rotundity in a highlight on flesh pink and ends in a fist as if delivering an uppercut. The right arm is merely signalled by a

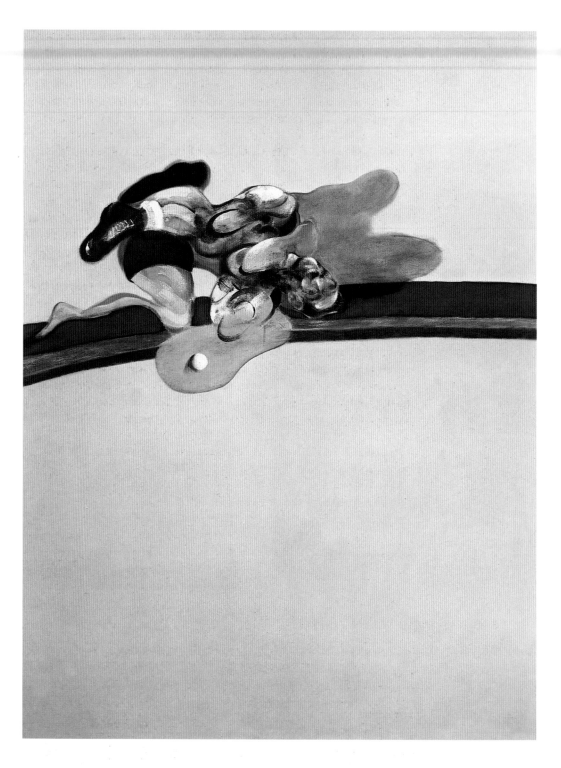

45 *Triptych* 1971 (detail)
Oil on canvas Left panel of three, 198 × 147.5 (78 × 58⅛)
Foundation Beyeler, Reihen/Basel

black outline among the general suggestion of thoracic musculature. The head either pulls the foreshortened perspective of the body around towards us or is dislocated. The eyes look up like a supplicant dog. So it goes on.

In other words, the painting stimulates our knowledge of the human body. It calls forth acts of instantaneous recognition below the level of thought comparable to our spontaneous actions when encountering people in the street, actions that answer such unspoken questions as: who is it, do they threaten me, do I desire them? Disruption brings these habitual reflexes into consciousness. Bacon sets up expectations of norms and fears of abnormalities. To refer back to Greenberg's argument (p.63), the paintings threaten nature speaking virulently through art, as does a photograph of some human freak or wound. Bacon collected and painted on photographs of such things. The instant horror, revulsion and fascination of these images attest that at some level we do experience them as real.

Horrific nature is imminent within the ambiguity of fractured pictorial conventions. In the *Triptych* 1971 panel, for instance, this is evident in the shifts from the linear to the painterly, such as the cartoon-like clarity of the boot and leg conjoined with the ambiguities of the thorax. The image incites a perceptual panic, a need to make sense, to conceptualise and to recognise. Nevertheless, it refuses to satisfy those needs unambiguously. Asked what does that depict, we might reply without thinking, 'it looks like a fallen boxer', but know that it was only the start of a discussion. To go back to Kant, this is not the common-sense unification of the faculties, but nor is it Deleuze's recognition-free sensation. It is the faculties in confusion.

46 *X12Recto, The X Album*
Paint and photographs and paper
Approx. 37.5 × 28.7 (14¾ × 11¼)
Irish Museum of Modern Art, Dublin, The Barry Joule Archive (Works on paper attributed to Francis Bacon)

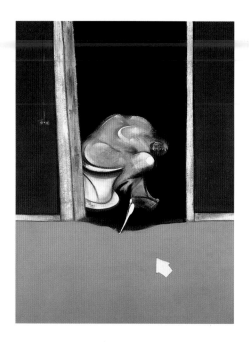
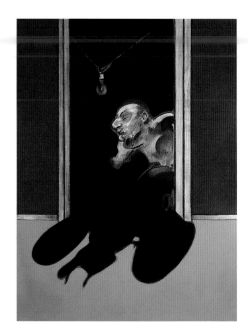

As Deleuze points out, the danger of representation in painting is that it is both illustrative and narrative. Realist images incite realist texts, prose in which events are part of a sequence, a narrative or some other form of what Bacon called a 'diatribe through the brain'.[7] Fractured representation, broken realism and disrupted illustration incite meanings in which narrative cannot function, and interpretation and common sense do not rule.

Biographical narrative threatens the paintings inaugurated by the death of George Dyer. George Dyer who died alone, full of booze and pills, sitting on the lavatory in their hotel room in Paris. Bacon told with variations the story of Dyer, the handsome uneducated petty criminal with a speech impediment he met in 1964; Dyer became his lover and drank himself to death on Bacon's money. His biographers have repeated the story, and it is the subject of the feature film by John Maybury, *Love is the Devil*, released in 1998. After Dyer's death in 1971 Bacon returned to Dyer's image repeatedly over the next four years. He is the subject of three triptychs, is portrayed in a fourth and appears in a number of other paintings.

Dyer's death is shown in *Triptych May–June*, 1973 (fig.47). A number of devices prevent the work from becoming like a cartoon strip. Dyer expires in the first frame in a conventional left to right narrative reading. The changing furniture of the black space further interrupts narrative continuity: a lavatory, a light bulb and then a sink. On the left and right panels the light switches are on different sides of the door. Arbitrarily, two arrows suggest the diagrammatic, as if this is a how-to-do-it illustration.

Is *Triptych* 1971 (fig.48) an autobiographical illustration? To refuse to recognise Dyer would be like refusing to recognise Rembrandt in his self-portraits or Marat in David's *Death of Marat* (1793). The crouched/fallen figure in the left

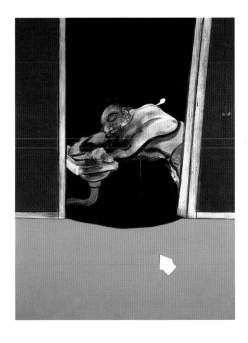

47 *Triptych May–June* 1973
Oil on canvas
Each panel 198 × 147.5 (78 × 58)
Private Collection

48 *Triptych* 1971
Oil on canvas
Triptych, each panel
198 × 147.5
(78 × 58)
Foundation Beyeler,
Reihen/Basel

canvas and in the right is perhaps Dyer, and Dyer's reflection spills over a table. The profile, down to the slick of hair at the back of his head, comes from a photograph of Dyer by John Deakin (fig.49). The central canvas is one of the most architecturally depicted spaces in all of Bacon's paintings. Dyer's shadow-like profile sits on the surface of the panel, disrupting spatial coherence. Picasso uses the same device in the top right of *The Three Dancers* (fig.50; one source of the wobble Greenberg deprecates in the painting). There are other spatial destabilising devices, the slant of the window, for instance, and the break in the door's receding perspective caused by the perfect circle of the Yale lock on the surface of the canvas. The arm that feeds the key into the lock traverses the

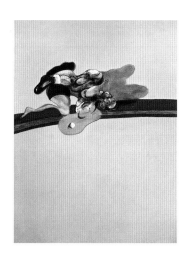

49 John Deakin
Portrait of George Dyer
Copy of photograph from Francis Bacon's studio
The Francis Bacon Estate

50 Picasso
The Three Dancers
1925 (detail)
Oil on canvas
215 × 142
(84¾ × 56)
Tate

back of the man at the door like the serpents in the first-century-AD statue of the sea monsters crushing Laocoön and his sons to death (*Laocoön and his Two Sons*, Vatican Museum, Rome).

Disrupting immanent realism saves the paintings from illustration, from story telling. Bacon's paintings work by the threat of illustration and by its disarrangement. In the words of the Russian Formalist critic, Roman Jakobson, modern literature is a kind of writing that represents an 'organised violence committed on ordinary speech'.[8] To enact its violence, literature needs ordinary speech. The paintings of Francis Bacon need illustration, or the figurative, for they aspire to the condition of modernist literature.

6

ERIC HALL AND THE POETS

I always feel I've been influenced by Eliot. The Waste Land especially and the poems before it have always affected me very much.[1]

<div align="right">Francis Bacon, Interview 6, 1979</div>

That arm feeding the key into the lock in *Triptych* 1971 is a motif Bacon had used before and was to use again. It alludes, Bacon said, to lines from T.S. Eliot's *The Waste Land*, first published in 1922:

> I have heard the key
> Turn in the door once and turn once only
> We think of the key, each in his prison
> Thinking of the key, each confirms the prison

In a corroboration of George Lukács's characterisation of the ontology of literary modernism quoted earlier (p.51) Eliot in his 'Notes' on *The Waste Land* appends a quotation from F.H. Bradley (1846–1924):

> My experience falls within my own circle, a circle closed on the outside; and, with all its elements alike, every sphere is opaque to the others that surround it ... In brief, regarded as an existence which appears in a soul, the whole world for each is peculiar and private to that soul.[2]

For Bradley it is impossible for two minds to know the world in the same way. The world is an interdependent whole, but, as we cannot know it in its totality, our acts of comprehension are inescapably partial. Language is a broken tool: between it and that of which it speaks falls the shadow of an unfathomable disjunction. Thus, in isolation we reach out to each other with the defective tools of language.[3] Given the central importance of the poem to Bacon, it is perhaps not too wilful to see his space frames as a realisation of the closed circle, a space unique and inescapable.

Eric Hall

The poets Bacon mentions in the Sylvester interviews are of Eric Hall's generation not of Bacon's. Hall was wealthy, a patron of the arts, an Epicurean and possessor of the classical education that Bacon, who regretted that he was unable to read ancient Greek, felt he lacked. Hall was at Marlborough School and then went up to Trinity College, Oxford, in 1909, though he was not an academic success. The dominant philosophical figure at Oxford at that time was F.H. Bradley. T.S. Eliot came to England to study his work there in 1914.

Perhaps Hall picked up something of the ideas of arguably the most funda-
mental influence on Eliot's world-view.

Hall was of immense help to Bacon. He bought his work and introduced
him to good food, wine, music and theatre, gave him an entrée into cultivated
circles, arranged exhibitions that included Bacon's work and defended it in
print. In the mid-1930s they became lovers and in 1947 Hall left his wife and
family to join Bacon. Bacon's relationship with Hall ended in the early 1950s.
Like Roy de Maistre, Hall became a Christian, but an Anglican not a Catholic.
'Of late he could be seen in the afternoon walking to evensong at Westminster
Abbey,' reported his brief *Times* obituary of 20 October 1959.

In part thanks to Hall, Bacon's social milieu in the 1930s was an upper-
class, educated – meaning at that time with an education grounded in Greek
and Latin – and culturally advanced bohemia. He went on to mix with the cir-
cle around *Horizon*. To be a culturally competent participant in such company
would require familiarity with a shared body of reading. Freud, T.S. Eliot and
the poets Bacon cites would be *de rigeur*. If there was in Bacon's mind a for-
mative idea of the audience for his work, its 'significant others', it was this
group of people.

Poets as Models

In 1945 Hall bought *Three Studies for Figures at the Base of a Crucifixion*, 1944
(fig.1), which he presented in 1953, as he did other works, to the Tate Gallery.
Three Figures at the Base of a Crucifixion, as has been said, was in part derived
from reading Aeschylus, but read in the light of William Bedell Stanford's
Aeschylus in his Style: A Study in Language and Personality, published in 1942.
The character of Stanford's translation of certain passages, for instance 'The
reek of human blood smiles out at me', is specifically connected by Sylvester to
the painting.[4] However, the influence of this book may have gone beyond the
translations it offered. The characterisation of Aeschylus and the discussion of
his borrowing from colloquial forms and medical terms as well as from past lit-
erature, all present a model of the poet that foreshadows Bacon's work and its
multiple sources. Stanford's summary of antiquity's view of Aeschylus trans-
lates into a description of Bacon and his painting:

> Archaistic yet self-willed and individualistic; contemptuous of popular
> taste; careless of poetic technique; having a noticeably 'architectural'
> quality; using a weighty diction that verges on pomposity; obscure;
> fond of long, strange, and astonishing words; prone to unevenness
> and incoherence; using harsh-sounding phrases and scorning
> euphonic devices; with daring imagery sometimes bordering on the
> grotesque.[5]

The importance of Eliot and Pound for Bacon is in part, likewise, as models of
how to be an artist. What distinguished art from other things, how to relate to
past art and present culture, to these and other questions their poetry and crit-
icism provided indicative answers which could be translated, but not tran-
scribed, into pictorial practice.

Bacon was a maker of images. He speaks of making images rather than of making paintings. He wanted the images to assault 'the nervous system', to have an instantaneous effect. 'An "Image" is that which presents an intellectual and emotional idea complex in an instant of time,' wrote Pound, and it is beyond the 'word formulated in language'.[6] In addition, he was to say in his essay on Henri Gaudier-Brzeska, 'an image is real because we know it directly'. Bacon was an Imagist, to use a flag under which Pound briefly sailed.

Bacon's motifs and the way he worked them resemble those of the poets he admired. Like Pound and Eliot, Bacon reworks classical themes, most conspicuously the Furies from Aeschylus's *Oresteia* as portrayed in William Bedell Stanford's commentary. His use of past art resembles Eliot's and Pound's quotes from and allusions to past literature and his use of photography relates to their employment of demotic speech. Rather than some Romantic, Expressionist or indeed Surrealist idea of spontaneous expression, Bacon's way of working enacts Eliot and Pound's insistence on poetry as an acquired art, an art of intellectual structure informed by the peaks and techniques of past literature.

In Eliot's much-cited essay, 'Tradition and the Individual Talent', from the collection *The Sacred Wood,* which appeared in 1920 and was subsequently much republished, the most famous passage reads: 'The more perfect the artist, the more completely separate in him will be the man who suffers and the mind that creates; the more perfectly will the mind digest and transmute the passions which are its material.'[7] Bacon may have sought an art that 'assaulted the nervous system' and depicted passions beyond reason, but his was a transmuting art, an art saved from illustration by calculation, an acute pictorial sensibility and intelligence. Written on the endpapers of a book that emerged after Bacon's death in what seem to be lists of paintings to be made, one entry reads 'figures on seat with raised as ape[,] use splashes on body'.[8] When Bacon said in 1953, 'I think that painting today is pure intuition and luck and taking advantage of what happens when you splash the stuff down', he was dissembling.[9] He was hiding the extent of his calculation just as he did in his denial that he drew. But calculation was at the core of what enabled him to create in the best of his painting a complex pictorial vivacity that transmutes the life of the man who suffered.

BACON'S DELAY

On Easter Saturday 1992 Bacon flew to Madrid where he was to die five days later. Barry Joule drove him to the airport. Joule, a Canadian of independent means with a science background, was a neighbour of Bacon's, and since 1978 he had become a friend (fig.51). He was interested in Bacon and art, and it was, recalls Joule, a pupil/teacher relationship. Bacon did not drive, so Joule drove Bacon around London and on trips to continental Europe. He helped the increasingly infirm Bacon with practical tasks in his flat and studio, including destroying rejected paintings. Bacon, says Joule, was always very precise with his instructions for the destruction of his works.[1]

On the morning of his departure Joule arrived to drive Bacon to Heathrow. Bacon handed him an old photograph album; a ribbon held it and its contents together. On the way to the airport Joule asked Bacon what he wanted him to do with the album. Bacon used a phrase he had used before when making a gift, 'you know what to do with it'. Bacon had removed the family snaps and filled the album with drawings in oil, often on collaged photographs. Four years later Joule started to make the work public by approaching various Bacon scholars and institutions. The emergence of this album and, from other sources, works on paper and previously unknown paintings put the predominant understanding of Bacon into question.

Apart from Picasso, one of the few twentieth-century artists for whom Bacon consistently declared admiration was Marcel Duchamp. Claiming to have given up making art, Duchamp kept secret the final work of his life, *Etant Donnés*. Its appearance in 1969 after his death disrupted the whole understanding of Duchamp. In an essay discussed by Bacon and Sylvester in one of the interviews Duchamp argued that art ceases to be art when the creative work of the spectator is over and the work's meanings and value have become established.[2] A work, Duchamp estimated, is art for only about twenty years. The appearance of Bacon's works on paper – sketches and drawings in oil paint, biro and pencil on paper, pages of books and photographs – disrupted the established accounts of Bacon. They change the history of the conception and execution of the paintings. There is now a new body of sources for his images. What is the aesthetic and monetary value of the works on paper? How do they relate to his other work? Are they all authentic? If he dissembled about his drawings, what else did he lie about? As I said at the beginning of this essay, Bacon scholarship is raw.

In the summer of 1999 an exhibition *Francis Bacon: Paintings from the Estate 1980–1991* was held in the second floor gallery of Faggionato Fine Art in Albermarle Street, London. The building overlooks the frontage of Marlborough Fine Art on the opposite side of the road. Shortly after Bacon joined

Marlborough in 1959, they moved to a new gallery in Bond Street. With their growing success, Marlborough bought and built their way through the block and eventually opened a frontage on the Albermarle side. At the same time Marlborough was making partnerships and opening galleries in Rome, New York and Zurich, in all of which Bacon was to have one-person exhibitions. In the same period that Bacon left the Hanover for Marlborough other artists, including Henry Moore, Barbara Hepworth, Ben Nicholson and Graham Sutherland, were leaving the galleries who had been promoting and selling their work for years and joined Marlborough. Marlborough offered to look after the day-to-day administration of the artists' affairs and provide a new level of international promotion, regular stipends and higher prices, of which the artist would usually get 50 per cent. Bacon gave the size of his debts and the lack of sympathy of Erica Brausen's backers for his work as his reasons for leaving the Hanover Gallery.

51 Barry Joule
Portrait of Francis Bacon 1982
Bacon photographed in 1982 standing next to a photograph of himself taken by Helmar Lerski in Berlin in 1928
Photograph
Barry Joule

Exhibitions in and purchases by prestigious art museums are primary indicators of an artist's reputation and future value. Marlborough built their reputation and that of their artists by putting on museum-like exhibitions in the gallery with catalogues modelled on those of the Museum of Modern Art in New York. They targeted museums as buyers for their artists' work. One marketing device was to arrange an exhibition in a museum as if it was a curatorially independent selection. In fact, Marlborough owned much of the work in these exhibitions. Thus, prestige and value accrued to the Gallery's holdings. Lee Seldes in her book *The Legacy of Mark Rothko: An Exposé of the*

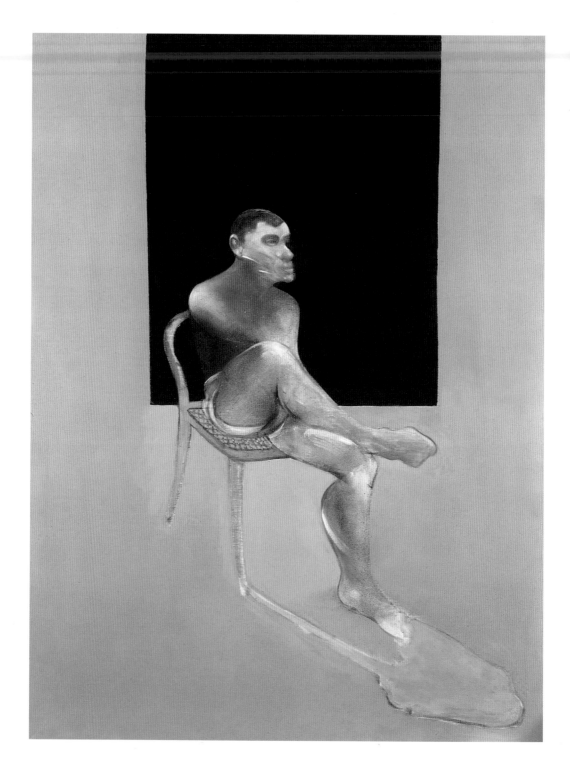

52 *Portrait of John Edwards* 1988
Oil on canvas 198 × 147.5 (78 × 58)
The Francis Bacon Estate

Greatest Art Scandal of Our Century cites a Bacon exhibition as an example.[3] She claims that the exhibition held at the Metropolitan Museum, New York, in 1975 consisted, with only three exceptions, of Marlborough-owned works. 'Your Gallery has never looked better,' one dealer is said to have remarked to Frank Lloyd, the co-founder of Marlborough, at the opening. 'Is the art market something that you dislike?' Bacon was asked in an interview. 'No, not particularly,' was his reply.[4]

The Faggionato exhibition of 1999 included *Portrait of John Edwards*, 1988 (fig.52). The painting echoes the posthumous paintings of George Dyer, but there are no virulent disruptions. The space in the painting is unbroken and perspectively coherent. The flesh-coloured shadow suggests no monsters of guilt. It is an old man's celebration of a young man made in the residue of a way of painting prompted by very different motives, and is one of many portraits of Edwards. Bacon had met him in 1974 when for a time Bacon had owned a house in the East End of London. Their relationship endured and was essentially paternal. It was to Edwards that Bacon left his estate, valued at more than £11 million. The relationship between the estate and Marlborough broke down, and the gallery end of the management of the estate passed to a New York dealer, Tony Shafrazi, and Faggionato Fine Art in London.

Bacon's closing years, wrote David Sylvester, 'were lightened by the society of a young, good-looking, cultivated Spaniard'.[5] Joule describes the relationship as tempestuous. He travelled to Madrid in his last days to rekindle this friendship but died there of a heart attack on 28 April 1992, nursed by two nuns of the Servants of Mary.

Notes

Introduction

1 Ray Monk, *Ludwig Wittgenstein: The Duty of Genius*, London 1991, p.302.

Chapter One: Pretexts for Despair

1 David Sylvester, *Interviews with Francis Bacon 1962–1979*, London 1997, p.133.

2 Michael Peppiatt, *Francis Bacon: Anatomy of an Enigma*, London 1996, p.103.

3 Sylvester, *Interviews*, p.83.

4 Ronald Alley and John Rothenstein, *Francis Bacon*, London 1964.

5 John Russell, *Francis Bacon*, London 1971.

6 Sigmund Freud, 'The Economic Problems of Masochism', *On Metapsychology*, The Penguin Freud Library Volume II, London 1991, pp.409–26.

7 David Sylvester, *Francis Bacon: The Human Body*, Hayward Gallery exh. cat., London 1998, p.95.

8 Quoted in Peppiatt, *Francis Bacon*, p.29.

9 Ibid., p.27.

10 Sylvester, *Interviews*, p.18.

11 Peppiatt, *Francis Bacon*, p.27

Chapter Two: Ideologies of Despair

1 Herbert Read, *Art Now*, London 1933, p.144.

2 Maynard Keynes, 'The Arts Council, its Policy and Hopes', *The Listener*, 12 July 1945.

3 Barry Joule, 'Francis Bacon: A Brief Memoir', *The Barry Joule Archive: Works on Paper Attributed to Francis Bacon*, Irish Museum of Modern Art exh. cat., Dublin 2000, p.8.

4 Russell, *Francis Bacon*, p.6.

5 David Ward, *Patrick White: A Life*, London 1991, p.149.

6 Heather Johnson, *Roy de Maistre: The English Years 1930–1968*, Rosevill East, NSW 1995, p.28.

7 John Rothenstein, 'Introduction', *Roy de Maistre: A Retrospective Exhibition of Paintings and Drawings 1917–1960*, Whitechapel Art Gallery exh. cat., London 1960, p.8.

8 Ward, *Patrick White*, p.174.

9 Isaiah Berlin, 'The Hedgehog and the Fox', *Russian Thinkers*, ed. Henry Hardy and Aileen Kelly, Harmondsworth 1979, p.60.

10 T.S. Eliot, 'Introduction', in Charles Baudelaire, *Intimate Journals*, trans. Christopher Isherwood, London, 1989, pp.xviii–xix.

11 Joseph de Maistre, *The Works of Joseph de Maistre*, selected and translated by Jack Lively, London 1965, p.291.

12 Ibid., p.294.

13 Ibid., p.192.

14 Sylvester, *Interviews*, p.182

15 In conversation with the author, summer 2000.

Chapter Three: Bacon's Difference

1 Quoted in Andrew Brighton and Lynda Morris, *Towards Another Picture: An Anthology of Writings by Artists Working in Britain 1945–1977*, Nottingham 1977, p.100.

2 Sir Lawrence Gowing, 'Francis Bacon', *Francis Bacon: Paintings 1945–1982*, exh. cat., National Museum of Modern Art exh. cat., Tokyo 1983, p.21.

3 Georges Bataille, 'La Bouche', quoted in Dawn Ades, 'Web of Images', *Francis Bacon*, exh. cat., Tate Gallery, London 1985, p.13.

4 Wyndham Lewis, 'Round the Galleries: Francis Bacon', *Wyndham Lewis on Art: Collected Writings 1913–1956*, ed. Walter Michel and C. J. Fox, London 1969, pp.393–4.

5 Sylvester, *Interviews*, p.114.

6 Albert Herbert, letter to the author, June 1999, Tate Gallery Archives.

7 'Transcript of a conversation between Richard Hamilton, David Alan Mellor and Nicola Roberts', *The Barry Joule Archive – works on paper attributed to Francis Bacon*, Irish Museum of Modern Art exh. cat., Dublin 2000, p.30.

8 Sylvester, *Interviews*, p.125

9 David Sylvester, *About Modern Art: Critical Essays 1948–97*, London 1997, p.16.

10 John Berger, 'Francis Bacon and Walt Disney', *About Looking*, London 1980, pp.111–18.

11 Alley and Rothenstein, *Francis Bacon*, p.00.

12 Berlin, 'The Hedgehog and the Fox', p.60.

13 Sylvester, *Interviews*, p.58.

14 R.B. Kitaj, *The Human Clay: An Exhibition Selected by R.B. Kitaj*, Hayward Gallery exh. cat., London 1976, p.5.

15 Clement Greenberg, 'Modernist Painting', *Clement Greenberg: The Collected Essays and Criticism, Volume IV: Modernism with a Vengeance, 1957–1969*, ed. John O'Brian, Chicago and London 1993, pp.85–93.

16 Clement Greenberg, '1968: Interview Conducted by Edward Lucie-Smith', *Clement Greenberg*, p.278.

17 Clement Greenberg, 'The New Sculpture', *Art and Culture: Critical Essays*, Boston 1965, p.139.

18 Georg Lukács, *The Meaning of Contemporary Realism*, London 1962, p.20.

Select Bibliography

Chapter Four: Crucifixions

1 Sylvester, *Interviews*, p.46.

2 Ades, *Francis Bacon*, p.13.

3 Sylvester, *About Modern Art*, p.177.

4 Sylvester, Ibid., p.173.

5 Sylvester, *Interviews*, p.12.

6 Peppiatt, *Francis Bacon*, p.190.

7 Peter Fuller, 'Raw Bacon', *Images of God: The Consolation of Lost Illusions*, London 1985, pp.63–70.

8 Michael Leiris, *Francis Bacon: Full Face and in Profile*, Barcelona 1987, p.17.

9 Sylvester, *Interviews*, p.64.

Chapter Five: Illustration, Deleuze and the Dyer Triptychs

1 Sylvester, *Interviews*, p.126.

2 Clement Greenberg, 'Picasso at Seventy-Five', *Art and Culture: Critical Essays*, Boston 1967, p.62.

3 Giles Deleuze, *Francis Bacon: Logique de la Sensation*, Paris 1981. Extracts have been published in translation; the quotations here come from those published in *Flash Art*, 112, May 1983, under the same title as the book.

4 Deleuze, *Flash Art*, p.15.

5 Quoted in Max Kozloff, 'Critical Schizophrenia and the Intentionalist Method', *Renderings*, London 1968, pp.301–2.

6 Ernst van Alphen, *Francis Bacon and the Loss of Self*, Cambridge Mass. 1993, p.56.

7 Sylvester, *Interviews*, p.18.

8 Roman Jakobson, quoted in Terry Eagleton, *Literary Theory: An Introduction*, Oxford 1983, p.2.

Chapter Six: Eric Hall and the Poets

1 Sylvester, *Interviews*, p.152.

2 T.S. Eliot, 'The Waste Land, 1922', *Collected Poems 1909–1962*, London 1974, pp.79, 86.

3 Richard Wollheim, *F.H. Bradley*, Harmondsworth, 1959.

4 David Sylvester, 'Review', *Looking Back at Francis Bacon*, London 2000, pp.19–22.

5 William Bedell Stanford, *Aeschylus in his Style: A Study in Language and Personality*, Dublin 1942, p.13.

6 Ezra Pound, *Literary Essays of Ezra Pound*, ed. T.S. Eliot, London 1960, p.4.

7 T.S. Eliot, 'Tradition and the Individual Talent', *The Sacred Wood: Essays on Poetry and Criticism*, London 1972, p.54.

8 Matthew Gale, *Francis Bacon: Working on Paper*, London 1999, p.80.

9 Francis Bacon, 'A Painter's Tribute', *Matthew Smith*, Tate Gallery exh. cat., London 1953.

Chapter Seven: Bacon's Delay

1 Interview with Barry Joule, 'Bacon: A Personal Memoir', *Art Review*, December/January 1999, pp.30–4.

2 Sylvester, *Interviews*, p.104.

3 Lee Seldes, *The Legacy of Mark Rothko: An Exposé of the Greatest Art Scandal of Our Century*, Harmondsworth 1979, p.263.

4 Francis Bacon, *In Conversation with Michael Archimbaud*, London 1993, p.28.

5 David Sylvester, 'Biographical Note', *Francis Bacon: The Human Body*, Hayward Gallery exh. cat., London 1998, p.98.

Ernst van Alphen, *Francis Bacon and the Loss of Self*, Cambridge Mass. 1993

Michael Peppiatt, *Francis Bacon: Anatomy of an Enigma*, London 1996

David Sylvester, *Interviews with Francis Bacon 1962–1979*, London 1997

David Sylvester, *Looking Back at Francis Bacon*, London 2000

Photographic Credits

Copyright Credits

Index